GRAVEYARDS
—— OF THE ——
WILD WEST
—— NEVADA ——

HEATHER L. MOULTON
AND
SUSAN TATTERSON

AMERICA
THROUGH TIME®
ADDING COLOR TO AMERICAN HISTORY

To all those who have traveled the Extraterrestrial Highway (literally or figuratively) searching for the weird and wonderful: keep traveling on, friends! To Sam and Dean— you should have been at the haunted Clown Motel in Tonopah.

~ Heather Moulton, author

For the curious—stay curious! For my beloved Outback for always getting us home safely from the many thousands of desolate, desert miles. And to Subaru for making a car I can't break!

~ Sue Tatterson, photographer

America Through Time is an imprint of Fonthill Media LLC
www.through-time.com
office@through-time.com

Published by Arcadia Publishing by arrangement with Fonthill Media LLC
For all general information, please contact Arcadia Publishing:
Telephone: 843-853-2070
Fax: 843-853-0044
E-mail: sales@arcadiapublishing.com
For customer service and orders:
Toll-Free 1-888-313-2665

www.arcadiapublishing.com

First published 2021

Copyright © Heather Moulton, Susan Tatterson 2021

ISBN 978-1-63499-341-8

Typeset in Trade Gothic 10pt on 15pt
Printed and bound in England

CONTENTS

PREFACE

Home, means Nevada, Home, means the hills,
Home, means the sage and the pines.
Out by the Truckee's silvery rills,
Out where the sun always shines,
There is the land that I love the best,
Fairer than all I can see.
Right in the heart of the golden west
Home, means Nevada to me.

~"Home Means Nevada," Nevada State Song

Death is the great equalizer, and, as a concept, it both fascinates and repels us. Similarly, cemeteries also captivate and sometimes terrify us. "Is that where I'll end up?" "Will anyone remember me?" For the average person, we hope that our family and friends will remember us and visit our final resting places, but for the famous (or infamous), they are often visited by multitudes—some there to pay tribute; others to find inspiration; still others want a glimpse of history.

While archeologists have established that Native Americans were inhabiting the Great Basin area of the United States (primarily Nevada, Utah, and some of California and Oregon) from about 10,800 BCE, it was the Spanish explorers who put present-day Nevada on the map in the 1770s, colonizing it as part of Mexico. After the Mexican-American War (1846–1848), the United States acquired the land that eventually became Texas, New Mexico, Utah, Nevada, Arizona, and California, which, along with Colorado, came to be known as the Wild West.

Nevada became a territory in 1848; it was incorporated as part of the Utah Territory in 1850. Nevada-area citizens wanted to separate from Utah, but with a population of only a few hundred, that proved impractical. However, like much of the Southwest, gold, silver, and other precious metals were found in Nevada in the

nineteenth century. Most notably, the first major discovery of silver in the United States, the Comstock Lode (1859), near what would become Virginia City, would draw financiers, pioneers, miners, cowboys, and outlaws.

After the silver boom in 1859, the population exploded, and Nevada became its own territory in 1861. Known at the time as the Battle Born State, Nevada became the thirty-sixth state in the Union on October 31, 1864—one of only two states (West Virginia being the other) added to the Union during the Civil War (and done so in order to ensure the reelection of President Lincoln by adding three electoral votes).

The unearthing of the Comstock Lode not only led to the development of Nevada as a populated state, but it arguably initiated the Second Industrial Revolution in the U.S., which began in the late nineteenth century. The original miners who discovered the Lode did not have the resources or experience to mine it and eventually sold their interests to the likes of George Hearst, William Chapman Ralston, and others who would become legendary industrialist-financiers in San Francisco. George Hearst was the father of William Randolph Hearst, famed journalism mogul. William Ralston founded the Bank of California and financed many mining operations around the Southwest. After the Second Industrial Revolution ended—with the start of World War I—and an economic bust in the early twentieth century, most of the populated areas that had exploded with mining and the railroad faltered and became ghost towns. When those towns flourished, so did their graveyards since mining deaths were frequent, and when they became ghost towns, the cemeteries remained, often unkempt but serving as a rich reminder of Nevada's history.

While western cemeteries are not as old or elaborate as those found on the East Coast (Boston, New York) or the Deep South (Charleston, New Orleans), they still represent an important part of Nevada antiquity and include some of the state's most celebrated or notorious residents. Even cemeteries without famous folks hold a certain charm: they are often nestled among idyllic valleys or mountains and far from the glittering glamor of Las Vegas.

I have long enjoyed visiting "old-timey" graveyards, and Nevada is rife with them. To me, they are beautiful and tragic, and they all have tales to tell. I hope the photos and stories in this book offer insight into Nevada's history and remind us to treasure each day we have in hopes that those who follow will continue to treasure our final resting places.

~ **Heather Moulton**
Chandler, 2021

WELCOME TO FABULOUS NEVADA: A GRAVE HUNTERS DREAM STATE (BONNIE CLAIRE & FORT CHURCHILL)

Quod tu es, ego fui;
quod nunc sum, et tu eris. ~Roman epitaph

As you are, so once was I.
As I am, you soon will be.
~"A Plea" featured on signs outside many Nevada cemeteries

Most people do not make it past Las Vegas. The glittering lights of Sin City are a beacon after traveling through miles of desert and darkness. The city boasts everything to appeal to everyone: shows, showgirls, shopping, slots, and scenery—most of it fabricated and then illuminated by millions of lights.

But Nevada is so much more than the Neon Capital of the World (and most of it is electric now anyway). In fact, the majority of the state around and beyond Vegas offers insight to the mining history that helped build the modern United States.

Some 160 miles north of Las Vegas and adjacent to Death Valley lies the ghost town of Bonnie Claire (also called Bonnie Clare, Thorp, and Montana Station). Perhaps no site in Nevada represents the opposite of Vegas—at least visually—as well as Bonnie Claire. The town was founded in 1881 and quickly became a milling location for three major mines in the area. The mines declined in 1914, which should

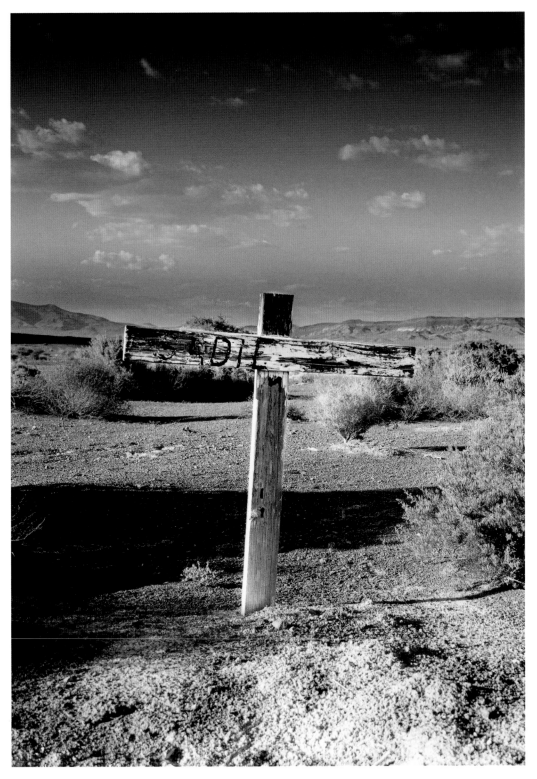

A makeshift gravemarker—likely for a dog—off of Highway 95 near Bonnie Claire.

have been the end of Bonnie Claire, but she was shortly revitalized when a Chicago millionaire named Albert Mussey Johnson began construction of a vacation home in Death Valley, only twenty miles from Bonnie Claire and across the California border. Johnson partnered on the project with prospecting legend "Death Valley Scotty," who insisted on the existence of a rich gold mine hidden in the area. All materials for the project, which would become known as Scotty's Castle (though Scotty never owned it, nor is it, technically, a castle), were delivered to Bonnie Claire via the railroad. When the railroad folded in 1928, so did Bonnie Claire.

All that remains of the mining town are ruins of the stamp mill, a few crumbling buildings, a glorious view of the Nevada-California desert, and three grave markers, one of which is probably a dog.

The **Bonnie Claire Burial Grounds** is difficult to locate; it is across Highway 95 from the mill. The first marker one may find—thinking it is the actual burying ground—is a wooden cross that says only "Sadie," most likely a beloved pet (since Sadie is a popular dog's name, and no other people are listed on Find A Grave).

After locating Sadie, the desert wandering—due to sketchy GPS instructions—begins (thanks to history enthusiast and explorer Nevada Bob for any GPS directions). With some luck and determination, eventually the grave markers of Dora C. Black and Dorothy Ione Patnoe can be located among the scrub brush and jack rabbit hollows.

No information on Dora C. Black is available—other than, according to her concrete cross headstone, she was born on March 10, 1898, and she died on November 29, year unknown—due to rust that has distorted the date on her name plate. More information is available on Dorothy Ione Patnoe, who was born on February 6, 1906, in Texas and died on April 4, 1911, of scarlet fever, according to Find A Grave. Why this woman and child were buried in the desert in the early twentieth century remains a mystery as there is no indication of any official Bonnie Claire cemetery or even additional graves near these two.

Continuing north on I-95 for another 246 miles will lead the desert adventurer to **Fort Churchill (or Post) Cemetery**, which is part of the Fort Churchill State Historic Park in Silver Springs. The Nevada State Parks' website explains that Fort Churchill was built in 1861 "to provide protection for early settlers and guard the Pony Express mail runs." The location was also a way station in the 1800s for travelers on the Overland Route, a 650-mile stagecoach and mail trail.

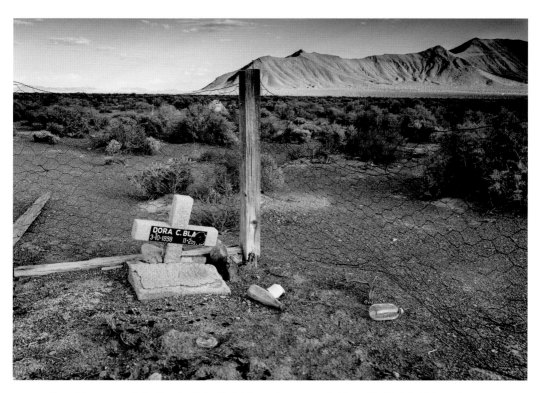

One of two graves at the Bonnie Claire Burial Grounds, surrounded by a dilapidated chicken wire fence.

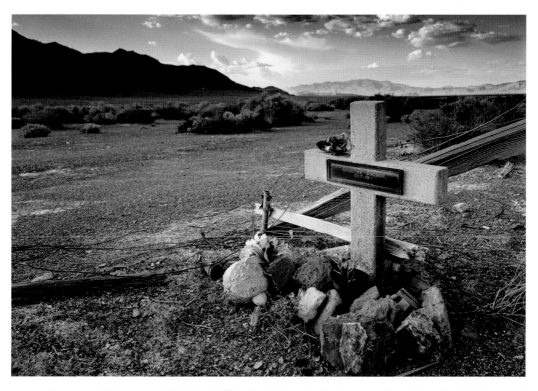

The second of two graves at the Bonnie Claire Burial Grounds; the Amargosa Range looms in the background.

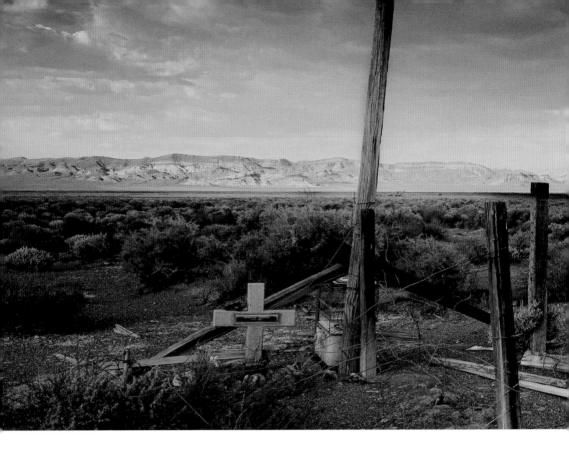

Nevada pioneer and Buckland family patriarch Samuel Sanford Buckland owned the ranch that would become the Overland Stage Stop, and, when Fort Churchill was abandoned in 1869, he bought the buildings. Some of the materials from the Fort were used to build the Buckland Station ranch home that would lodge the family and serve as a boarding house and school.

Samuel, his wife Eliza, and five of their eight children are buried at the Fort Churchill Cemetery, which is a serene little graveyard bordered by a white picket fence and watched over by the glorious open northern Nevada sky.

Find A Grave lists sixteen memorials; however, according to the informational sign outside the cemetery, "The Post Cemetery was the final resting place for soldiers killed in local battles and those who died from exposure, illness, and hardship. In February 1885, more than fifteen years after the fort's abandonment, the remains of forty-four soldiers were removed and reinterred in the Lone Mountain Cemetery in Carson City, Nevada."

A few souls remain in the graveyard along with the Buckland family, including Daniel Burier who died at age thirty-five and an "Unknown Soldier," according to his

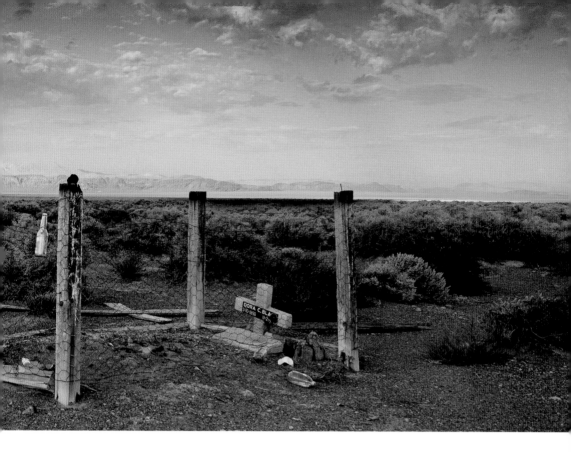

marker. Others laid to rest here have no plaques, but the details of their deaths reflect the lawlessness too common in the Wild West. Henry Genie died in a "murderous affray at Carson [City]" in 1862; pioneer David Carlyle died in 1862 during a "fatal affray near Churchill," Thomas Stead was beaten to death in 1861 by (allegedly) Fort Churchill soldiers after he refused to give them liquor.

Fort Churchill State Park is a worthy stop on the way to Carson City for those interested in learning about Nevada history or enjoying a pleasant day in nature. The Nevada State Parks' website asserts, "With 3,200 acres along the Carson River, the park is an idyllic place for campers, hikers, bird watchers, canoeists, and equestrians."

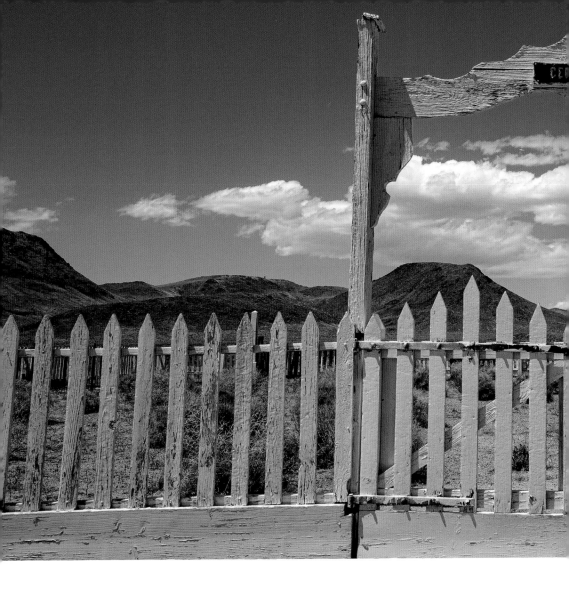

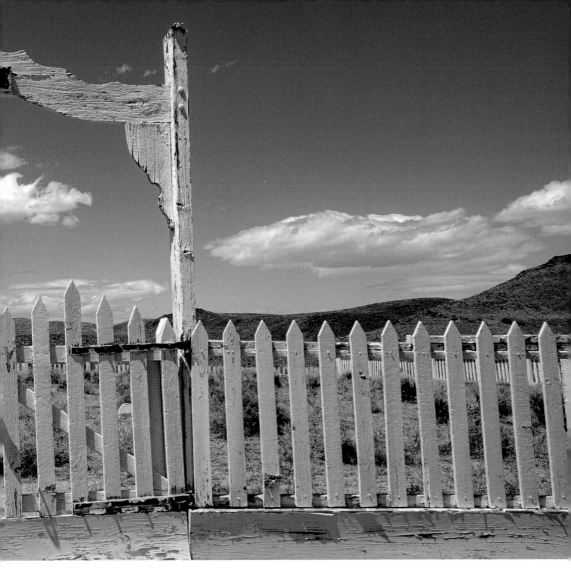

The white picket entrance to the Fort Churchill Cemetery.

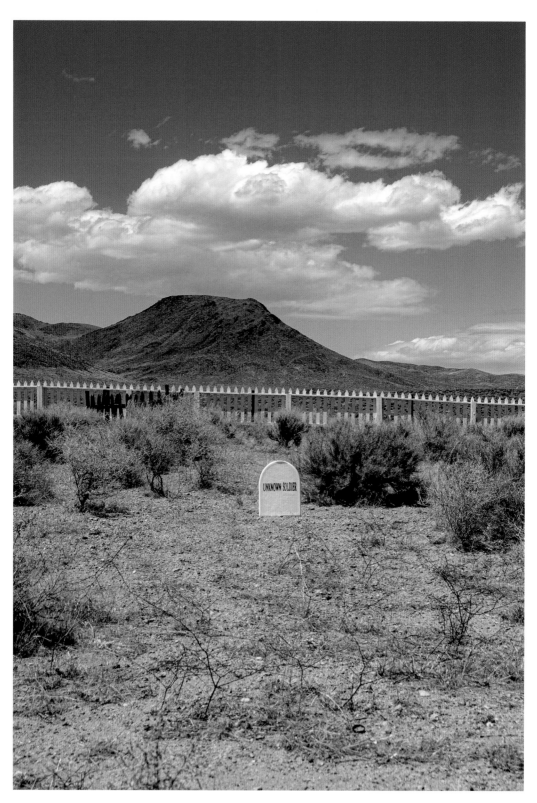

The remains of most Fort Churchill soldiers were removed in 1885, but this unknown soldier lingers.

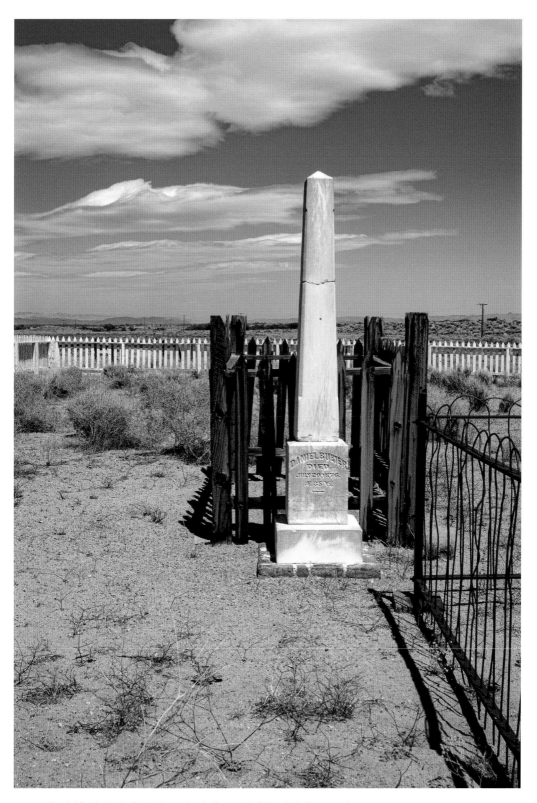

Daniel Burier's obelisk-style marker is the most elaborate in the cemetery.

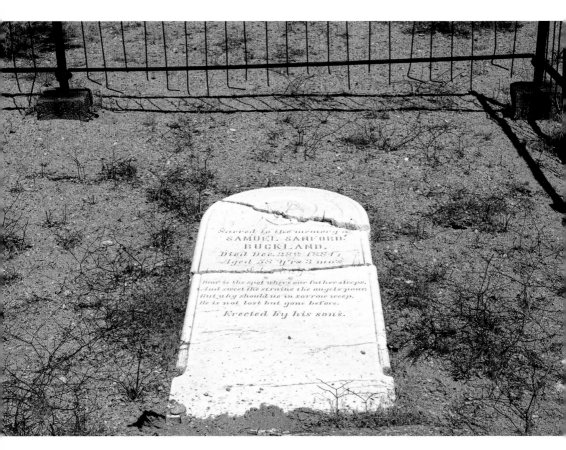

The Buckland family patriarch, Samuel Buckland, was an important local citizen.

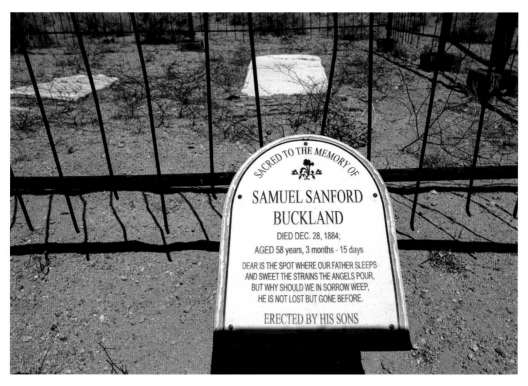

Because the original tombstones have toppled, each member of the Buckland family has an informative plaque.

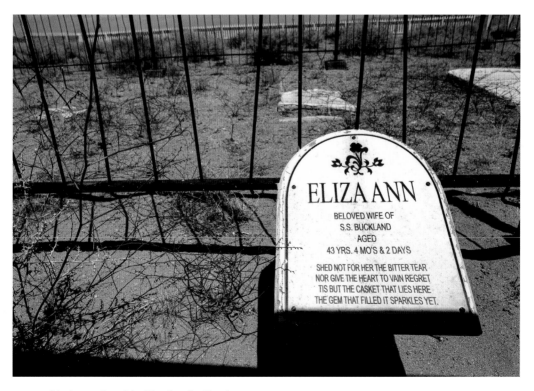

A loving sentiment for Eliza Ann Buckland.

GOLDFIELD CEMETERY
ESTABLISHED EARLY 1900s

Gold mining man
In the hills above
Your search for gold has been your heart's only love
Gold mining man
I feel your pain and hurts
But who will your gold belong to when you leave this Earth?

~Clint Anderson, "Gold Mining Man"

Goldfield was originally called Grandpa. According to legend, the earliest miners called it that because it was supposed to be the "granddaddy" of all mining camps. However, prospectors and investors in the area thought that a name like Goldfield would better promote the mining district and town. Goldfield lived up to its name; it produced 4.2 million high-grade gold ounces after its founding in 1902.

With the discovery of gold, the town grew rapidly between 1904 and 1908 and became Nevada's largest city at that time, peaking at 20,000 inhabitants. Wild West legend Virgil Earp, one of the participants of the famous Tombstone, Arizona, O.K. Corral showdown with the Clanton Gang, was sworn in as sheriff in January 1905, and there is debate as to whether or not his brother Wyatt lived in Goldfield, too, or just visited. Unfortunately, Virgil contracted pneumonia in February and died of a relapse at the hospital in Goldfield in October 1905. He is not buried in the Goldfield Cemetery as his remains were sent to Oregon at the behest of his daughter.

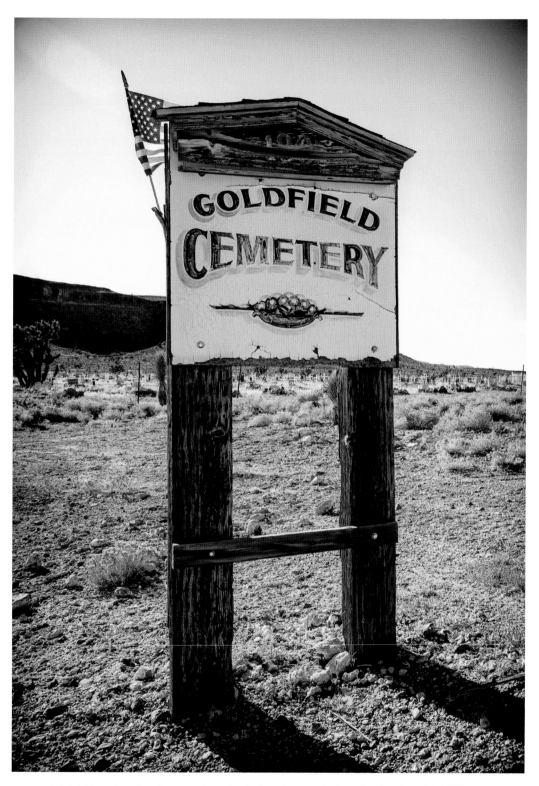

Goldfield Cemetery sign; the warped wood at the top obscures the founding date (possibly 1905).

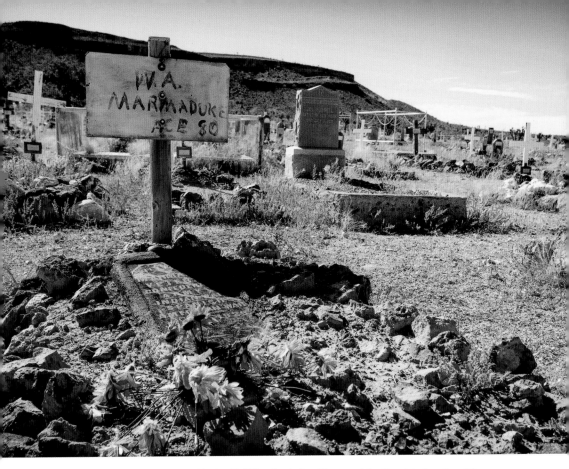

William A. Marmaduke served in the Civil War, the Indian Wars, and the Spanish-American War.

Even without an Earp, the Goldfield Cemetery is, according to the Travel Nevada website, "chock full of some of the most interesting history in Nevada." The original graveyard was located in the center of town, but when the railroad came through and the town boomed, the city and railroad officials thought it prudent to relocate the remains to where they rest now, on the edge of town. Those original souls, between 70 and 155, depending on the source, are part of the pioneer section of the cemetery, which is adjacent to the main cemetery.

Nevada cemeteries include some of the most detailed grave markers, clearly demonstrating that the state values and works to maintain its history. One of the most commonly photographed bright-white headstones in the pioneer section reads, "Unknown Man Died Eating Library Paste, July 14, 1908." While humorous at first glance, the reality is much grimmer. Find A Grave reports that the man was a starving vagrant who found the paste in a trash can. The paste was made mostly of water and flour, but it also contained a chemical called alum, which can be poisonous in large doses.

More violent deaths pepper the pioneer section. Edward Hughes died while in the Esmeralda County Jail from "self-strangulation." Benjamin Nugent, aged thirty-nine, and Ed Carnes, aged forty, died of gunshot wounds. Martin Rowher died of a gunshot in 1908, this time from the deputy sheriff. Many of the headstones leave much to the imagination. For example, who was Indian Molly, A. Bosznanin, or General James Murphy? Their markers give no more information than the one that says "Unknown Man."

The main cemetery has more than 1,300 memorials and includes a combination of traditional marble tombstones, cement slabs, white-painted rocks, wooden and metal crosses, and boothill- and military-style markers. The cemetery is divided into different sections, including the Catholic section (Sacred Heart), Elk's Rest, and the Knights of Pythias area.

Like most Wild West mining town cemeteries, Goldfield's citizens permanently departed for various reasons, from mining accidents, to gunshot wounds, to diseases, to suicide, to graveyard mishaps, to a flood that initiated the final demise of the town.

Canadian-born Capt. W. L. McDougal died after falling into a mine shaft; young Richard Berryman, aged twenty-two, was killed when he was hit by a falling rock while working in a mine; William T. Juleff died of electric shock in a mine. George W. Gilliam, a saloon keeper; Richard Maunsell, a mining engineer; Earnest W. Priest, a mine pump man; and Antonio Toravani, a World War I veteran, all died of gunshot wounds on the streets of Goldfield. Albert E. Jarvis died at age fifteen from an accidental gunshot. William B. Andrews, a.k.a. the Button Nose Kid, "reached the end of the rainbow" from tuberculosis. The tin marker on miner John King's wooden cross indicates that "life became a burden," which is a gentle way of saying he committed suicide. One wooden grave marker is for John F. Meagher, a grave digger and cemetery sexton, who died at age seventy-three in 1918 after a rock hit him from blasting (rather than digging) a grave. In 1913, a massive flood swept through Goldfield, claiming the lives of five people, including Eulalia Robeles, a laundry worker, aged fifty.

Baby Girl Mahana is one of several infant deaths in the cemetery; only one date—November 3, 1910—graces her grave. A slightly weathered stuffed bunny sits atop her marker. On the other hand, a veteran from the Civil War (1861–1865, Confederate Army), the Indian Wars (1860s), and the Spanish-American War (1898), William A. Marmaduke, lived to be eighty years old.

Immigrants from Mexico (Jesus Regalado), Germany (Conrad George), Ireland (Michael Charles Gormly), Scotland (Alexander Gail Monroe), Italy (Mike Korich), and former Yugoslavia (Anto Vukajlovich) all rest together in the Goldfield Cemetery. Folks also traveled across the United States and ended their days in Goldfield, originating from Indiana (Mayo Taylor), Illinois (A. V. Murray), Kentucky (Edward Glendon), New York (Carrie Sawyer), and Michigan (William T. Walker).

Love and lust may also be found in the Goldfield graveyard. Lucy Heslip was born Maragreta Apollonia Lorenz in Germany in 1878. She died on August 16, 1909, "taken before her time." Next to her lies her husband Thomas Heslip, a chemist-assayer, born in 1863 in Ireland. He died the next day on August 17, 1909, because he "couldn't live without Lucy."

Madame Beverly Harrell is remembered as "a fearless beauty of class and intellect"; in 1967, she founded the Cottontail Ranch—a brothel—in Lida Junction, Nevada, and ran it until her death in 1995. Her marble headstone features an imprint of a rather innocent-looking bunny holding a flower.

One mysterious inhabitant of Goldfield Cemetery is Col. D. E. (Daniel Elliott) Huger Wilkinson, 1851–1913. The tin plate on his grave marker indicates that he was born in South Carolina and died in Tonopah, Nye County, Nevada. It also says that he is the great-grandson of Arthur Middleton, a signer of the Declaration of Independence. Wilkinson is not listed on Find A Grave, and no information about his military service or his history can be located. The rest of the Huger-Wilkinson-Middleton clan lived and died in South Carolina. What drove Wilkinson west? War? Gold? His story appears lost to history (and even the Internet).

Goldfield has a current population of around 250 and is considered a "near" or "neo" ghost town. After fires in 1923 and 1924 wiped out numerous buildings and claimed at least two lives, Goldfield could not recover. The town is worth a visit; the Chamber of Commerce says, "Visitors will get a sense of what it was like to live in [a] gold rush boomtown in [the] early 20th century. Today much still remains to explore and investigate." GoldfieldHistoricalSociety.com offers a walking tour booklet of the "World's Greatest Gold Camp."

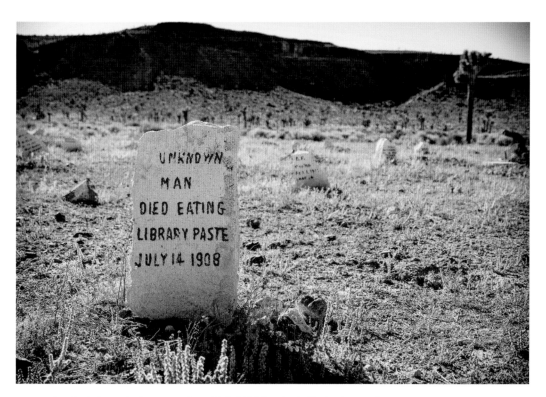

An oft-photographed grave marker with Goldfield's mine in the background.

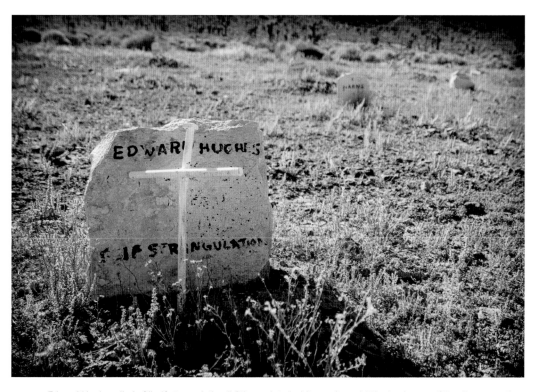

Edward Hughes died of "self-strangulation." Other painted white markers dot the landscape of the pioneer section.

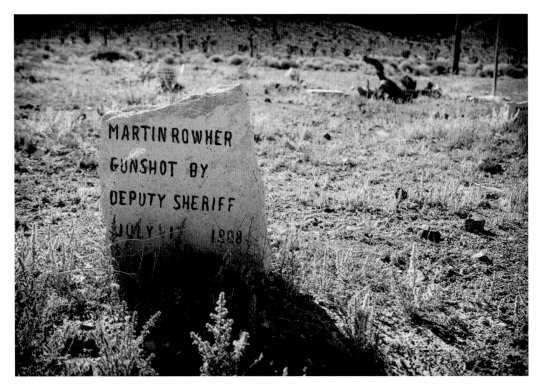

Martin Rowher was killed by the deputy sheriff in 1908.

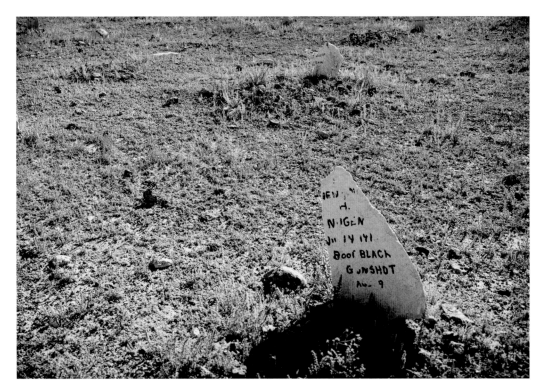

Benjamin Nugent was a boot black, which means he shined shoes.

Young Albert Jarvis died of an accidental gunshot wound..

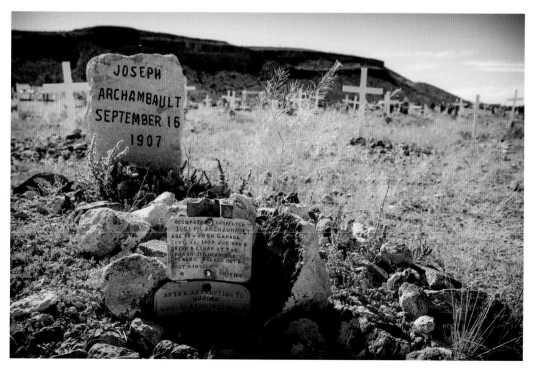

The tin plaques explain that Joseph Archambault committed suicide after attempting to murder a woman.

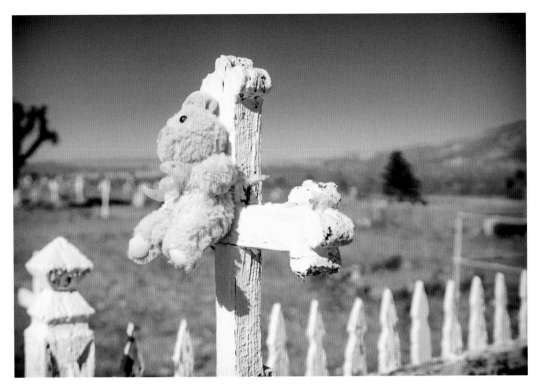

A tattered teddy bear indicates a child's grave.

Beautiful chunks of stone and purple glass bottle bits brighten Hazel McKenzie's grave.

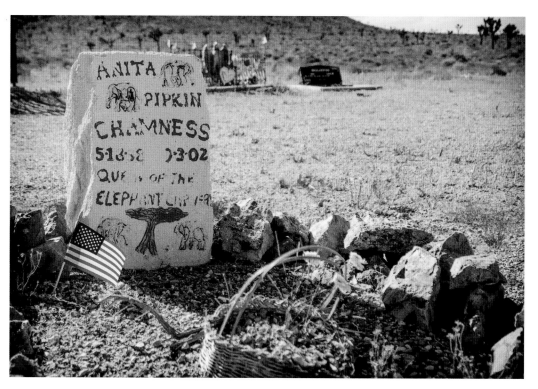

Anita Chamness: "Queen of the Elephant Charmers." A new American flag adorns her grave.

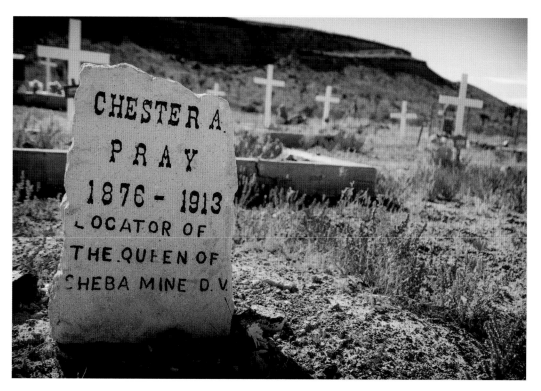

The last member of a pioneer family, Chester Pray, died of an accidental gunshot wound, ending his family line.

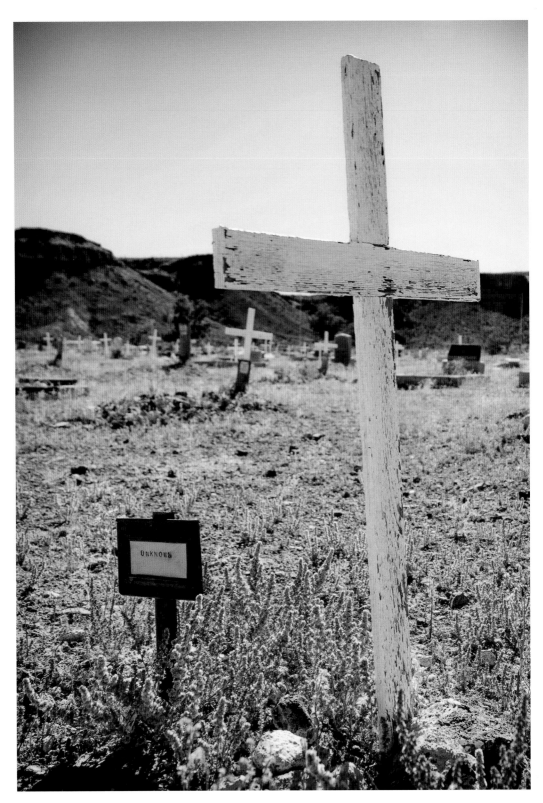

A white wooden cross designates one of many unknown souls who rest in the Goldfield Cemetery.

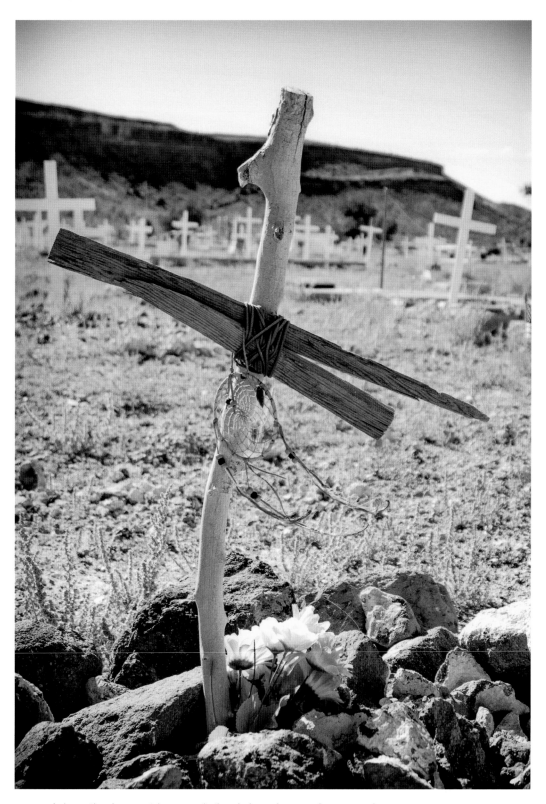

A decorative dream catcher sways in the wind on a homemade grave marker.

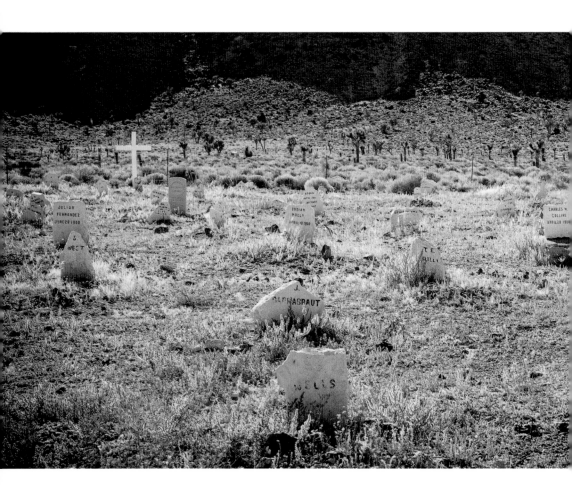

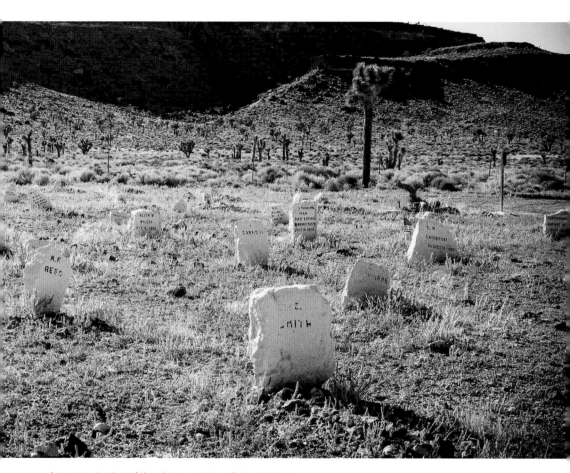

A panoramic view of the pioneer section of the cemetery.

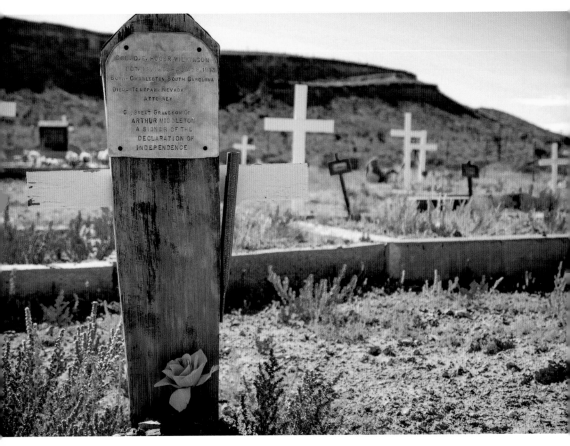

Above: A modest grave for Col. D. E. Huger Wilkinson, the great grandson of a signer of the Declaration of Independence.

Opposite page: A weather-worn teddy bear rests with John L. Berkey, who was twenty-four or twenty-five years old at the time of his death.

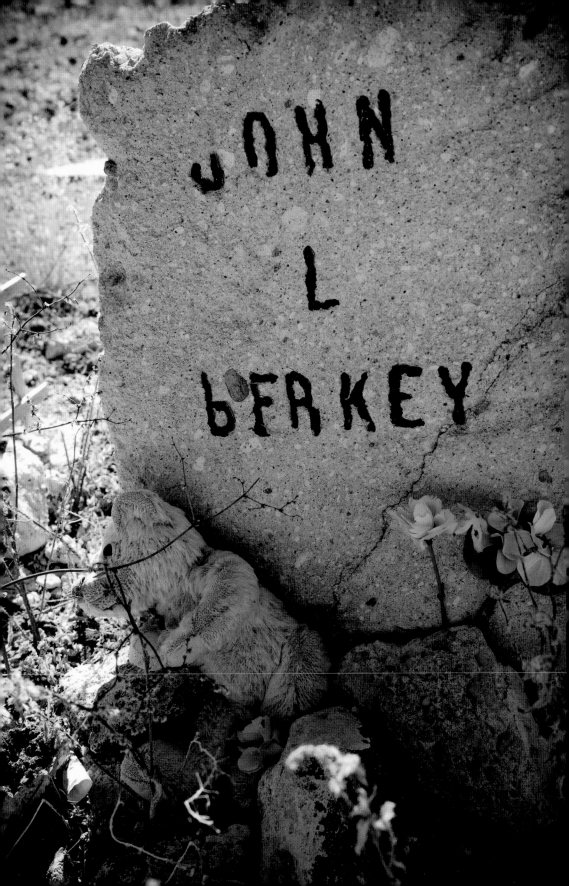

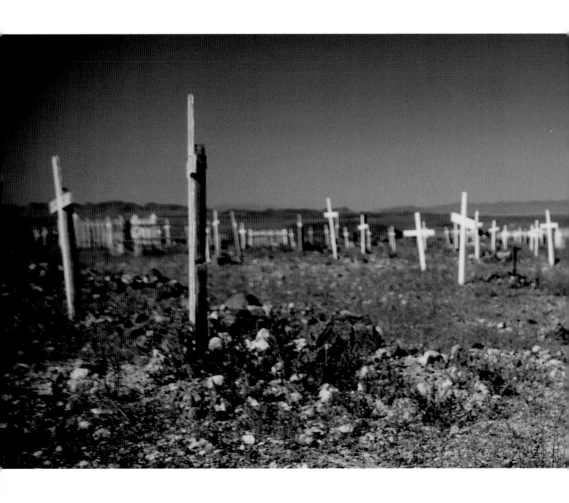

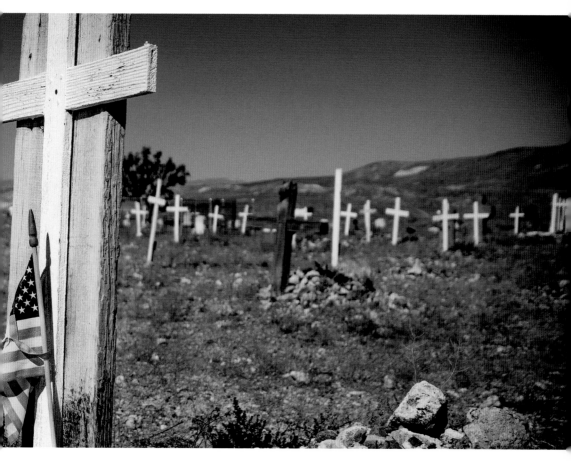

A threadbare American flag offers the only color to contrast the Nevada desert.

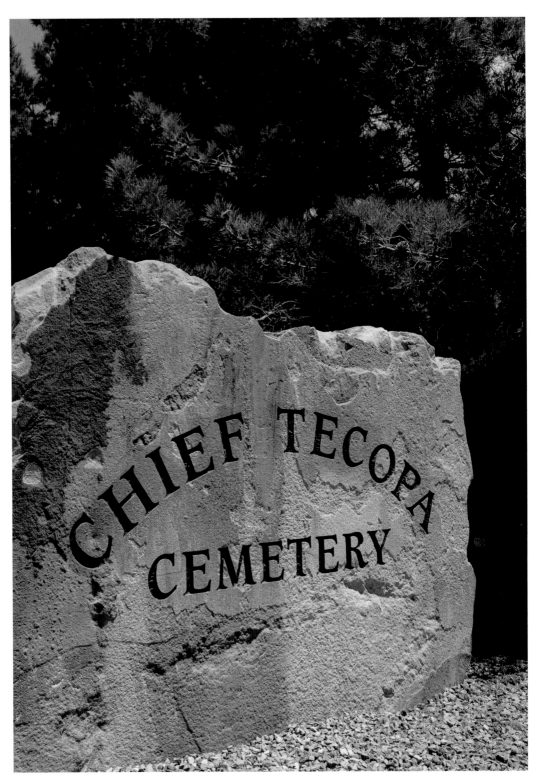

The entrance to the Pahrump/Chief Tecopa Cemetery, named in honor of the Southern Paiute chief who worked to maintain peace between his people and white settlers.

PAHRUMP CEMETERY

CHIEF TECOPA CEMETERY (A.K.A. PAHRUMP COMMUNITY CEMETERY), ESTABLISHED DATE UNKNOWN

"We will be known forever by the tracks we leave."
~Proverb, Santee Sioux Tribe

The Wild West was won not only through the grit and adventurous spirit of pioneers and outlaws, but by the forced relocation and near-annihilation of Native peoples. The original inhabitants of Nevada consisted of four tribes: the Washoe (Wa She Shu), Northern Paiute (Numu), Western Shoshone (Newu), and Southern Paiute (Nuwu). Those tribes remain today, though their numbers have been significantly reduced since the eighteenth century.

As reflected by all relations between Europeans and Natives in the United States, the contact between the white settlers and the Native Nevada tribes was troubled. However, in one small area of southern Nevada, the interaction between the Paiute Indians and white settlers went from combative to relatively nonviolent thanks to two men who worked out a treaty: Chief Tecopa, "The Great Peacemaker," of the Southern Paiute tribe and "Captain" John Moss, an explorer, mountain man, Pony Express rider, prospector, and community builder. They worked together as peacekeepers in Pahrump.

Pahrump is an unincorporated town in Nye County, sixty-two miles west of Las Vegas and eight miles east of the California border. Visit Pahrump.com explains, "It was originally named 'Pah-Rimpi,' which means 'Water Rock' due to the abundant artesian wells throughout the valley." Because of Pahrump's location near Las Vegas, as Sin City grew, so did Pahrump, jumping from 2,000 residents in 1980 to 38,000 in 2015.

The Chief Tecopa Cemetery is located near the intersection of State Route 160 and State Route 372; it is surrounded by an active city, complete with five casinos and several fireworks shops. Unlike so many Wild West graveyards, Chief Tecopa is beautifully manicured and maintained. It is divided into sections—distinguished by engraved red rock boulders (probably quarried locally since Red Rock Canyon is only thirty-three miles east)—including Veterans, New West, West Side, and Indian Site.

The man for whom the cemetery is named is buried in the Indian Site section. While his grave is unremarkable, there is a large, blue State of Nevada historical sign to demarcate it from other interments. The sign reads, "Chief Tecopa was a young man when the first white man came to southern Nevada. As the leader of the southern Paiute tribes, he fought with vigor to save their land and traditional way of life. He soon realized, however, that if his people were to survive and prosper, he would have to establish peace and learn to live in harmony with the foreigners. During his lifespan, which covered almost the entire 19th century [1815–1906], his energy and time were devoted to the betterment of his people. Chief Tecopa is honored for the peaceful relations he maintained between the Southern Paiute Indians and the white men who came to live among them."

More than 1,300 memorials are located within the cemetery. Chief Tecopa may be the earliest-born soul (1815) in the graveyard, but it's another nearby occupant who was the longest-living: "Beloved Great Grandpa Whispering Ben" was born in 1822 and died April 10, 1939, according to his engraved marble headstone, making him 117 years old.

There are numerous veterans resting here from World War II (1939–1945), such as Dale M. Arnold in the Indian area; the Korean War (1950–1953), including Roy Leon Stewart in the New West section; and Vietnam (1955–1975), for example Robert W. Nelson, who also served in World War II and Korea.

Children's graves dot the landscape, too. Baby Nicholson has a humble marker with no clear birth or death dates. Kodi Poe lived only one day, November 10, 1995; he has a simple plaque and a wooden cross to commemorate his location. Emilio Jose Ruiz was only four months old when he passed in 1999. He has a homemade tombstone with part of Victorian poet Christina Rossetti's funeral poem etched into it: "Miss me a little, but not for long/And not with your head bowed low/Remember the love that once we shared/Miss me, but let me go./For this is a journey we all must take/And each must go alone./It's all part of the master plan/A step on the road to home."

Pahrump is located in a valley, surrounded by the Spring Mountain range to the east and the Nopah Mountains to the west. Visit Pahrump.com touts the town's many attractions: stay and play at the hotel-casinos, experience off-roading adventures,

participate in the balloon festival, savor vintners' varietals at the local wineries, celebrate culture and heritage at the annual social powwow, or tour the Pahrump Valley Museum.

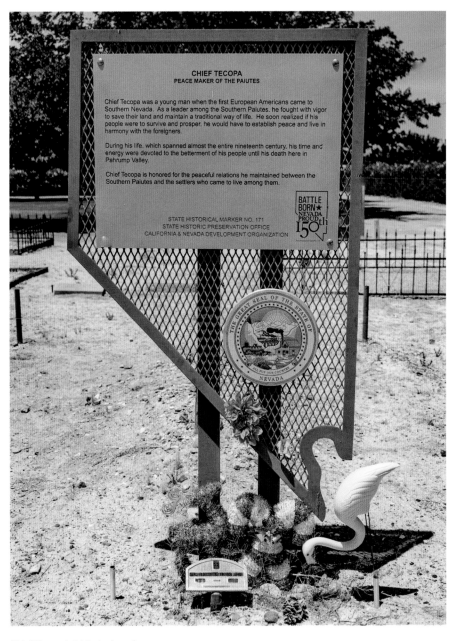

Chief Tecopa's historical marker.

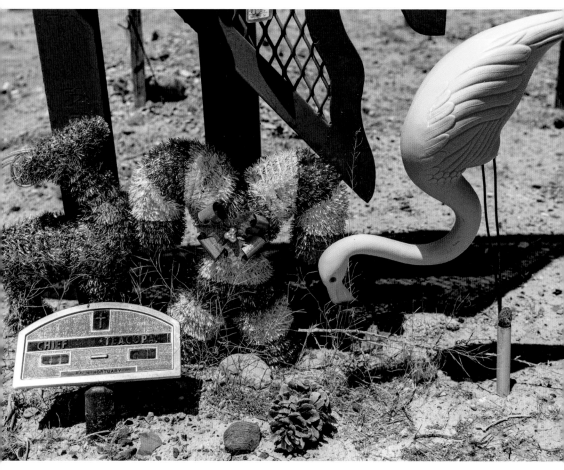

While Chief Tecopa's marker is modest, people have spruced up his grave with holiday decorations and a pink flamingo.

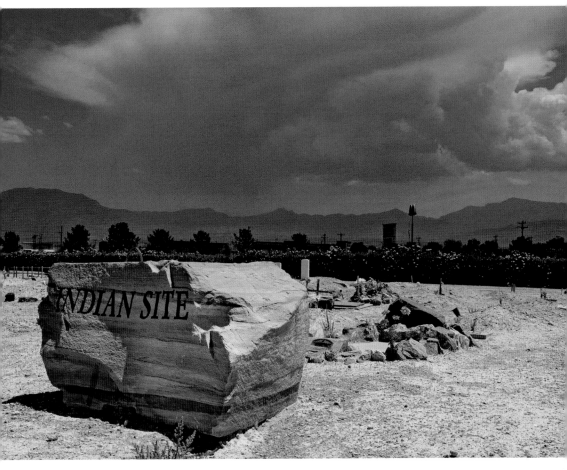

The Indian Site section of the cemetery with one of two mountain ranges that surround Pahrump in the background.

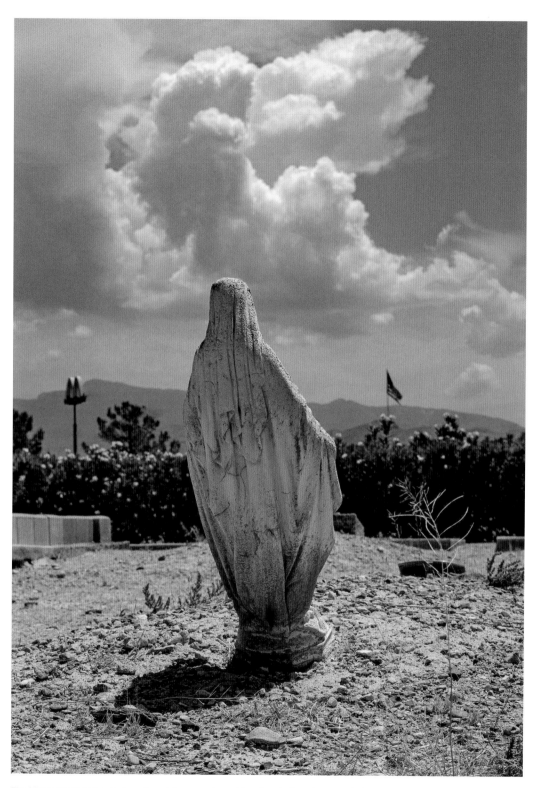

The Virgin Mary statue looks out past the cemetery at two iconic American symbols:
the McDonald's golden arches and Old Glory.

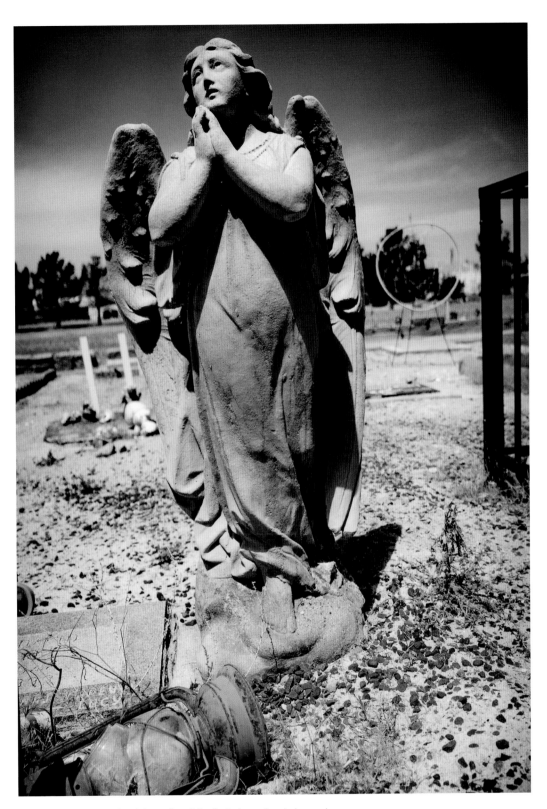

A discarded miner's lamp lies at the feet of a melancholy angel.

A homemade cross in remembrance of Kodi Poe, who lived only one day.

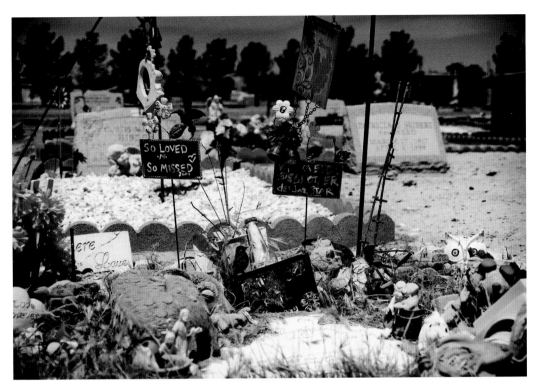

Messages of love for Emilio Jose Ruiz who lived only four months.

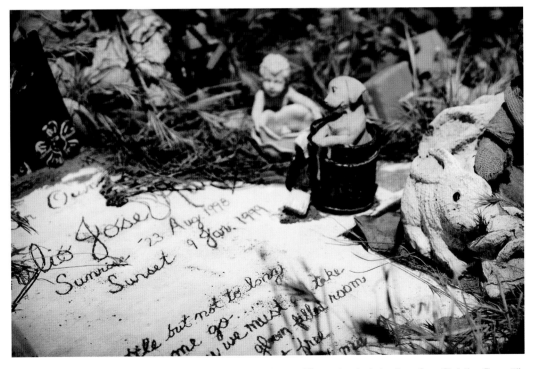

Emilio Jose Ruiz's grave is bedecked with children's toys. His marker includes lines from Christina Rossetti's funeral poem.

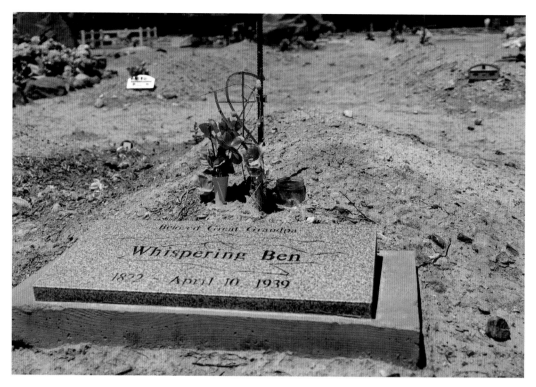

Whispering Ben lived 117 years.

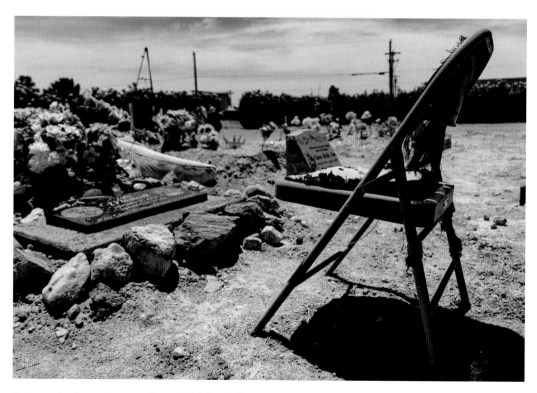

Perhaps a family member uses the metal folding chair to visit with a loved one.

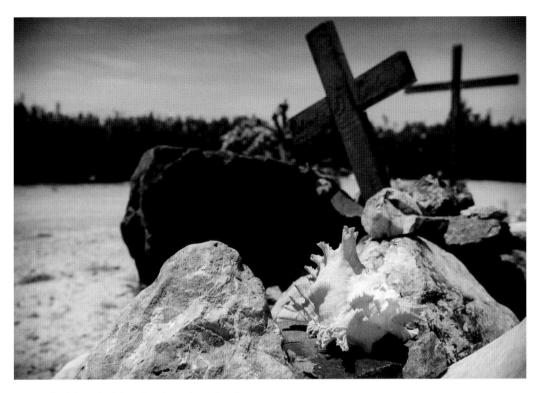

A mishmash of desert and sea elements adorn a grave.

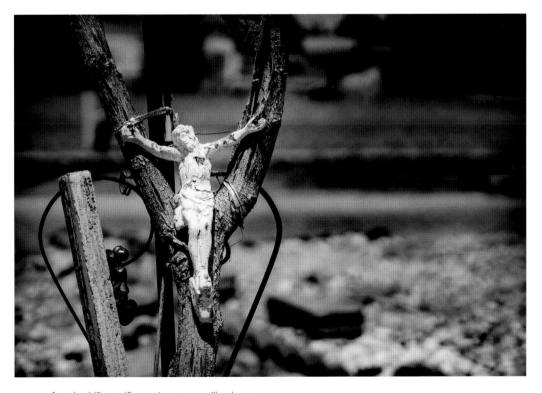

A makeshift crucifix creates a compelling image.

SCHURZ PAIUTE INDIAN CEMETERY,
ESTABLISHED DATE UNKNOWN

"I want my people to stay with me here.
All the dead men will come to life again.
Their spirits will come to their bodies again.
We must wait here in the homes of our fathers and be ready to
meet them in the bosom of our mother."
~Wovoka

Schurz is the only town on the Walker River Paiute Reservation in midwestern Nevada, almost 350 miles from glittering Las Vegas. The reservation, established in 1874, consists of about 325,000 acres in the Great Basin and is home to more than 1,200 residents, most of whom live in Schurz. The Agai-Dicutta Numu ("Trout Eaters People") are one of few American tribes who—through intense negotiations—were able to remain on their ancestral land; their name comes from the trout found in the Walker River, which provided a steady diet to the ancient people.

Schurz has a small cemetery that is still used today. Of the seven hundred memorials, the most renowned person interred is Wovoka, the Paiute mystic considered a messiah to his followers and founder of the Ghost Dance religious movement among Native Americans of the late nineteenth century.

Wovoka was born in 1856 near what is now Carson City. His father was a medicine man named Tavibo, who, around 1870, prophesied that all white people would be swallowed up by the earth, and all Natives would be reborn into a world free of

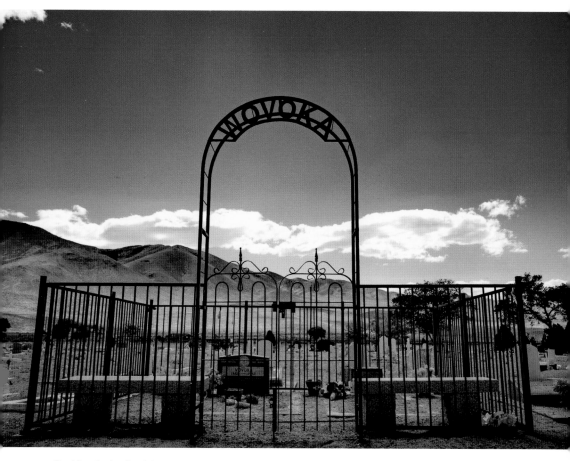

The Wovoka family plot.

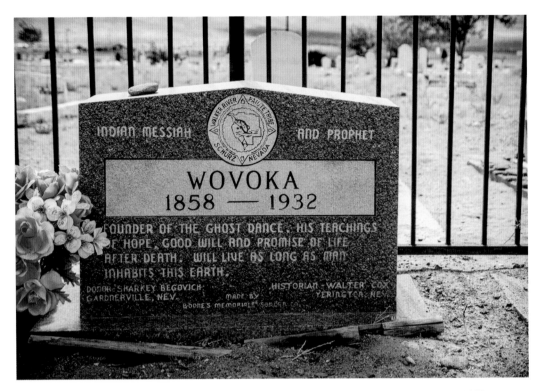

Believing Wovoka deserved a proper tombstone, Nevada businessman Sharkey Begovich donated one in the 1990s.

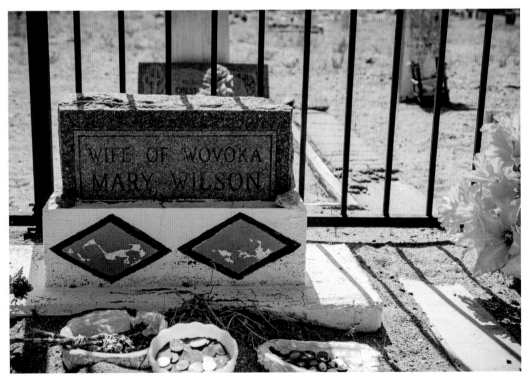

Tokens left to honor Wovoka and Mary Wilson.

conquerors. Tavibo died when Wovoka was young; Wovoka was then taken in by white ranchers, the Wilson family, and given the name Jack Wilson.

Following in his father's footsteps as a seer and shaman, Wovoka received a prophetic vision in the late 1800s, entailing the resurrection of the Paiute dead and elimination of white settlers from the land. From this prophesy was born the Ghost Dance, a traditional circular dance performed by males, which, along with non-violent and righteous behavior, would usher in a new era for Native Americans. Wovoka offered peace and hope to a people who had been displaced and slaughtered by white invaders; he gained popularity quickly, especially among the Lakota Sioux of North and South Dakota.

The Lakota followers of the Ghost Dance added an additional element to the religion: sacred shirts—said to be bulletproof—to be worn during the dance. The shirts were made of buckskin and often brightly dyed and decorated with images evoking nature spirits and the tribe's fallen dead. The symbols, materials, and rituals of creating the garments were said to infuse the clothing with supernatural powers. The Bureau of Indian Affairs agents tasked with monitoring the Lakota interpreted the attire and dance as militaristic and sent tribal police to arrest Chief Sitting Bull to force him to stop the dance. Sitting Bull was killed in the encounter, along with some of the policemen. Upon learning of the situation, the United States government sent the Seventh Cavalry to Wounded Knee, South Dakota. On December 29, 1890, the soldiers opened fire on the Lakota Sioux, killing more than 200.

Understandably, after the Massacre at Wounded Knee, the Ghost Dance religion and Wovoka lost popularity. However, Wovoka continued to preach non-violence and peace between all races and religions. He died in Yerington (about twenty miles from Schurz) in 1932 and was interred in Schurz Paiute Indian Cemetery. For many years, Wovoka's grave marker was deteriorating. In the late 1990s, Sharkey Begovich, founder of Sharkey's Casino in Gardnerville, Nevada, donated a new marble headstone and surrounding iron fence. The marker reads, "Founder of the Ghost Dance. His teachings of hope, good will and promise of life after death will live as long as man inhabits this earth." Wovoka's wife of fifty years, Mary Wilson (1865–1932), is buried next to him. Both graves are decorated with offerings (coins, jewelry, sage, colorful stones, flowers, etc.) from pilgrims who continue to visit the Indian Messiah.

The sprawling cemetery is peaceful and diverse in its foliage and monuments. One area is filled with shade-providing trees and elaborate marble headstones while another is starkly barren with wooden crosses, homemade cement gravestones and boothill-style markers. The Nevada wind blows across the valley, whipping into action the many miniature American flags that adorn the numerous veterans—from World War I, World War II, Korea, and Vietnam—buried in Schurz.

The Walker River Paiute Reservation and the cemetery are not tourist attractions, and respect should be given whenever traveling on Native land. The Agai-Dicutta Numu host an annual Pinenut Festival in Schurz each September. NativeAmerica.travel explains, "The Tribe hosts the Annual Pine-nut Blessing on the third weekend in September of each year. The Blessing features the best singers and beautiful songs for the Pine-nut Blessing Ceremony. This is a time-honored event when Tribal members come home and Indian people from many nations come to partake in the blessed event. It is a full weekend of activities for everyone. The Festival [includes] a Talent Show, Pow Wow, Fun Run, Kids Games, Indian Car Contest/Parade, Horseshoe Contests, Arm Wrestling, Stick Games, and Cradleboard Contest."

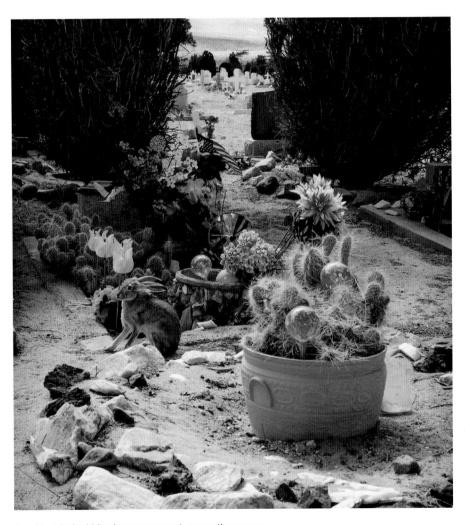

A resident jackrabbit relaxes a moment among the graves.

A deteriorating boothill-style marker.

Hot Nevada weather wears down wooden grave markers.

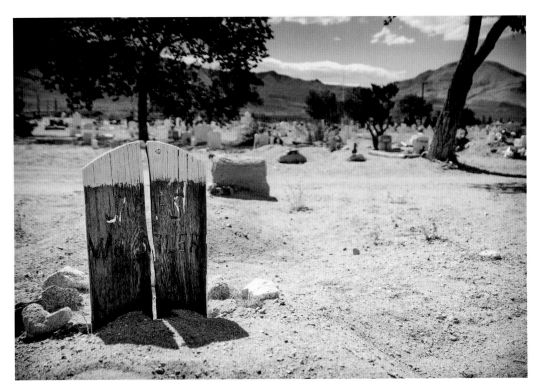

James Whistler was born in 1895; his death date is unknown.

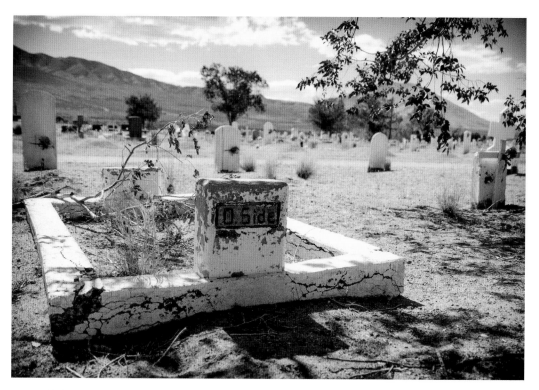

D. Side's grave is being reclaimed by desert brush.

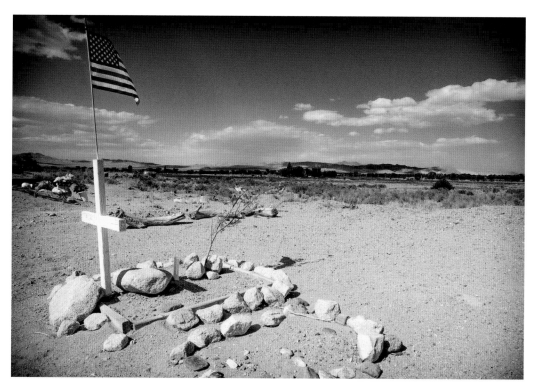

An unknown grave in the foreground; part of the Walker River Indian Reservation in the background.

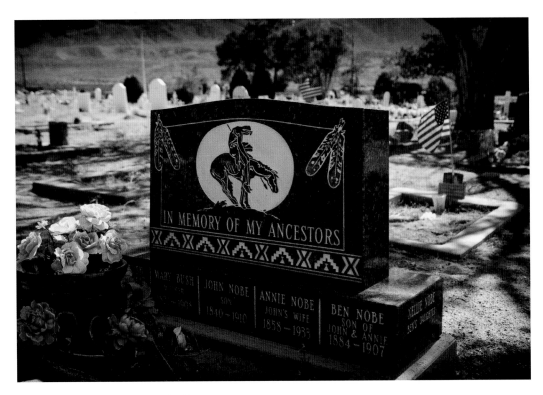

A memorial to the Bush and Nobe families.

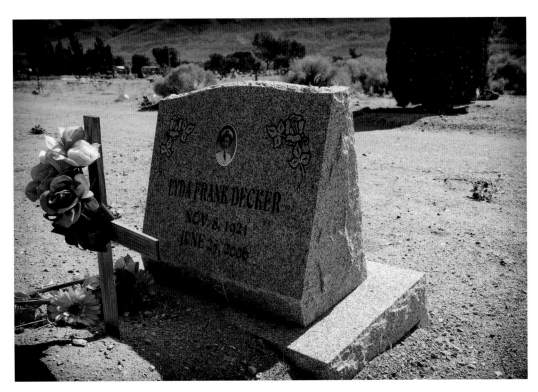

Lieutenant Commander Decker served in the Korean and Vietnam Wars.

Pieces of natural turquoise decorate a modest grave marker.

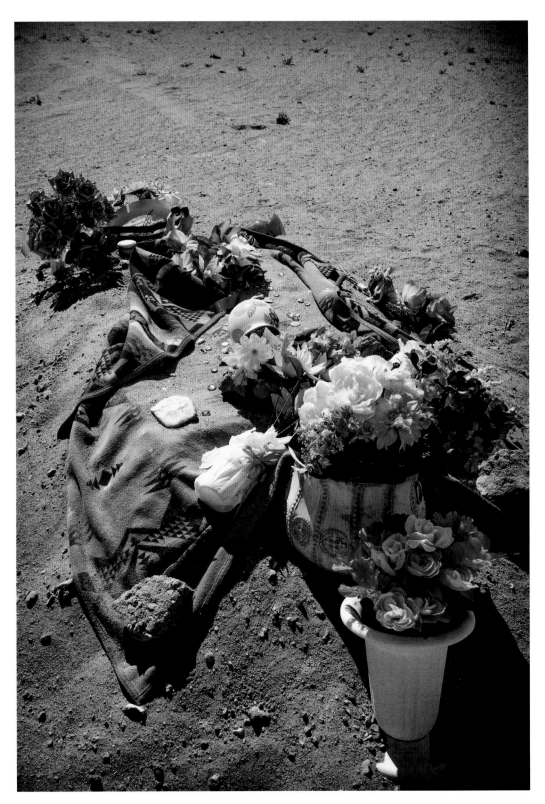

A blanket with Native American designs covers a recent grave.

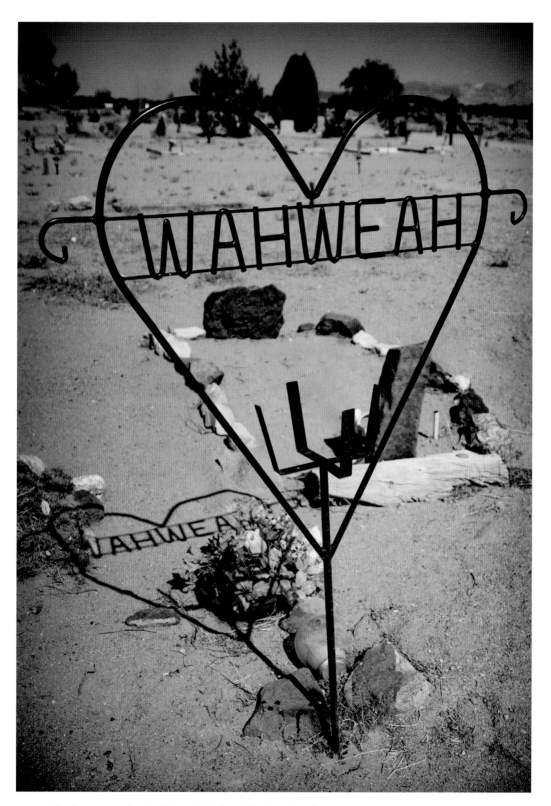

A unique marker for the Wahweah family—Albert and Lorraine.

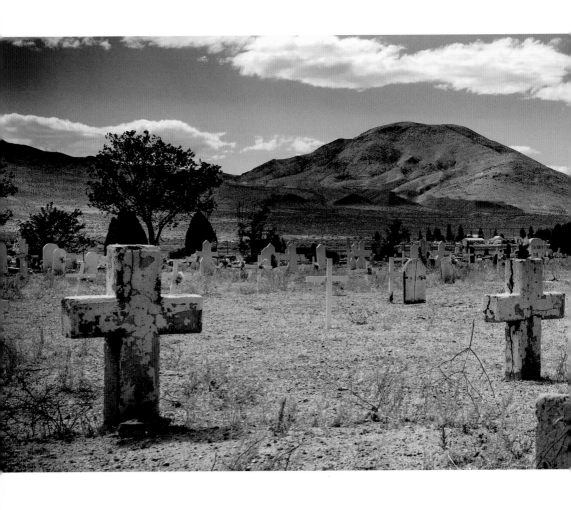

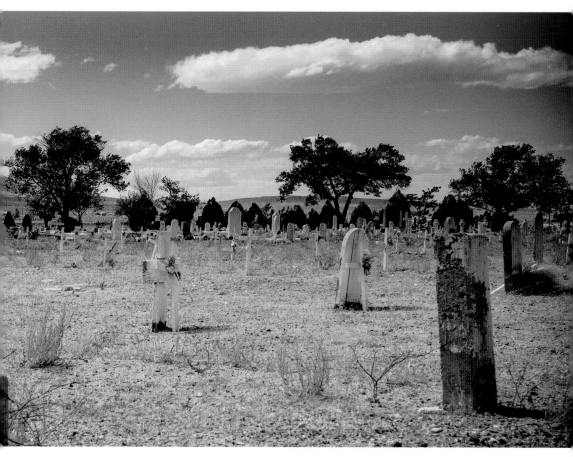

A stunning panoramic view of the cemetery.

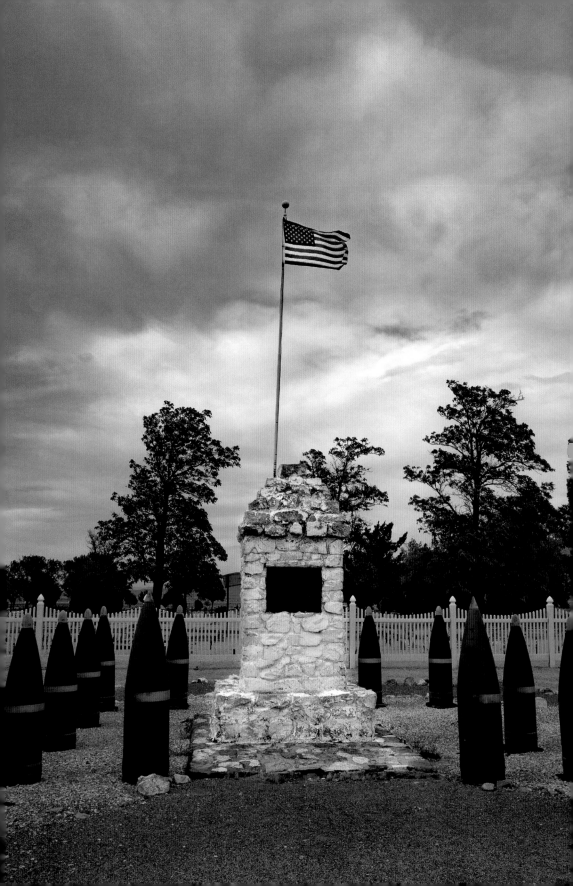

HAWTHORNE CITY CEMETERY

ESTABLISHED 1881

Praise the Lord and pass the ammunition
Praise the Lord and pass the ammunition
Praise the Lord and pass the ammunition
And we'll all stay free.

~Kay Kyser, "Praise the Lord and Pass the Ammunition"

Hawthorne sits along U.S. Route 95, 124 miles from Reno to the north and 315 miles from Vegas to the South. Founded in 1881, it has been a railroad town, a short-lived mining town, a near-ghost town, and a military town. Today, it remains home to a government ammunition depot first run by the Navy, then the Army, and finally, since 1980, a private contractor. The number of inhabitants of Hawthorne has fluctuated, from its low point of 244 residents in 1920 to its peak of 13,000 in the 1940s.

What resurrected this small town that should have become a ghost town after its single mine faded? A tragedy at a munitions depot in Lake Denmark, New Jersey, saved Hawthorne. An explosion at the Lake Denmark Naval Ammunition Depot (NAD) in 1926 killed twenty-one people, seriously injured fifty-three others, and nearly annihilated the NAD. The Navy needed a new depot; thanks in large part to the persuasiveness of Nevada Senator Tasker L. Oddie—who also happened to be a member of the Naval Affairs Committee—construction of the Hawthorne NAD began in July 1928. It received its first shipment of high explosives in 1930. U.S. Naval Reservist Dennis Cassinelli writing for the Elko Daily Free Press explains that the Hawthorne NAD "helped the United States to win World War II and the Korean

War" through its manufacturing and distribution of vast amounts of state-of-the art ordnance.

Megg Mueller of *Nevada Magazine* describes the enormity of the area and the peculiar feelings it may engender: "It sits on 147,236 acres, has 414 buildings, and 2,094 magazines that provide an explosive storage capacity of 7,685,000 square feet … the site of the bunkers laid across the valley can elicit an eerie Cold War vibe." It truly is a stunning, and intimidating, sight; one moment a traveler is driving through empty desert and suddenly thousands of bunkers dot the landscape.

Hawthorne's fascinating history may be slightly overshadowed by its present conspiracy. While entering Hawthorne from the south, a bright blue sign announces, "Naval Undersea Warfare Center Hawthorne Detachment." While it is not entirely unusual to have Naval training centers inland (*versus* on a coast), and Walker Lake is just north of Hawthorne, conspiracy theorists have speculated about a secret underwater submarine base. Here's how the story goes: near Point Dume, a promontory on the coast of Malibu, California, aerial photography has "revealed" a potential opening in the ocean shelf, which, some people conjecture, is where submarines enter an undersea waterway that concludes at Walker Lake (at the north end of Hawthorne), nearly 395 miles away. Considering Nevada's penchant for conspiracy theories, this one seems about as reasonable as alien spacecraft in Area 51.

Not including secret military personnel, the town of Hawthorne has a current population of just under 3,000, and the "Cold War vibe" remains. The town is adorned with military paraphernalia, including art installations made from dismantled ordnance, a multitude of American flags, shops painted red, white, and blue, and various decommissioned artillery scattered about the town.

In fact, outside the entrance to the Hawthorne City Cemetery stands a military memorial surrounded by twelve warheads. It is a beautifully kept graveyard with more than 2,800 souls at rest. The earliest graves show births from the 1830s and 1840s, and the cemetery remains in use today; it is the only cemetery in the small town, which serves as the seat of Mineral County. Markers range from elaborate marble and granite, to in-ground and traditional upright military, to bright white obelisks, to homemade concrete memorials.

Like so many cemeteries in the Southwest, the gravestones demonstrate diversity. Chew George Leong (1896–1924) has an elaborate marble headstone with Chinese characters. Ida C. Mayes was born in 1832 in Germany and died in 1885. Her marker says she was "A loving wife" and "A good mother." Serentius August Aaroe (1852–1893), a member of the Masons, was born in Norway. Callisto (1896–1957) and Ortensia Bigongiari (1895–1977) hailed from Italy before ending their days in Hawthorne, residing there since 1936.

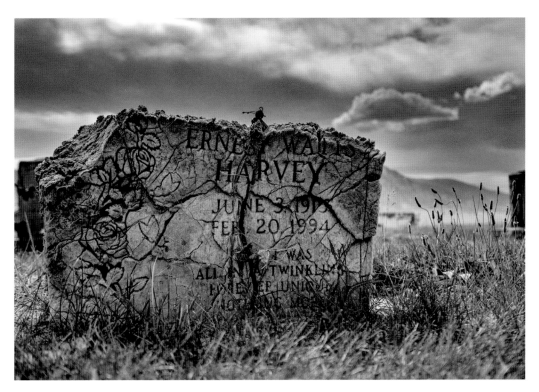

A stormy Nevada sky towers over a debilitated grave marker.

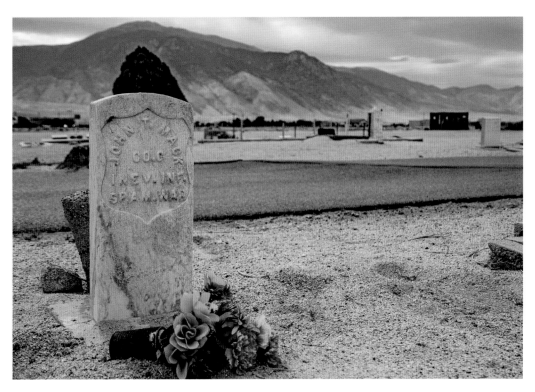

Silk flowers embellish a Spanish-American War veteran's military grave.

One section of the cemetery is designated as "God's Little Angels," a heartrending area with graves dedicated to infants and children. Stuffed animals and fading flowers offer a stark reminder of life's brevity, and too often, tragedy.

Military personnel from the Spanish-American War (John T. Mack), World War I (David Louis Kuska), World War II (William L. Adams), and Operation Iraqi Freedom (Kenneth Bostic earned a Bronze Star and Purple Heart; he was killed in action in 2006) can also be found in Hawthorne Cemetery. Eugene (Gene) Robertson—a baseball player for the St. Louis Browns, the New York Yankees (when they won the World Series in 1928), and the Boston Braves—served in both World War I and II.

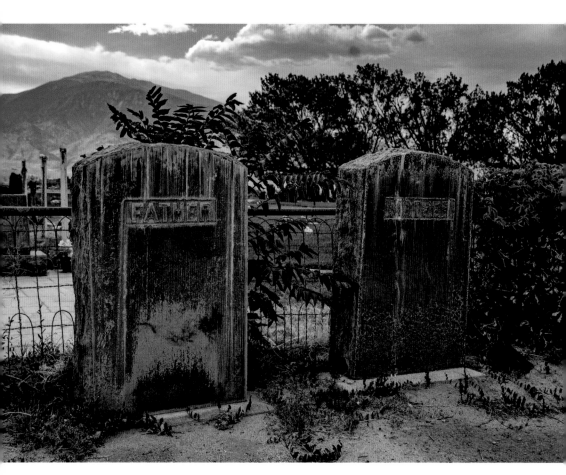

An anonymous Father and Mother rest side-by-side.

Hawthorne is a wonderful little burb in west-central Nevada with plenty to keep a vacationer occupied. The El Capitan Casino claims to be "The hot spot between Reno and Las Vegas." The Hawthorne Ordnance Museum "is the single largest museum collection of inert ordnance, missiles, bombs, rockets and nuclear weapons in the world." The Mineral County Museum houses antiques and historical documents. The more adventurous spirit may be interested in a helicopter tour, available at the Hawthorne Municipal Airport.

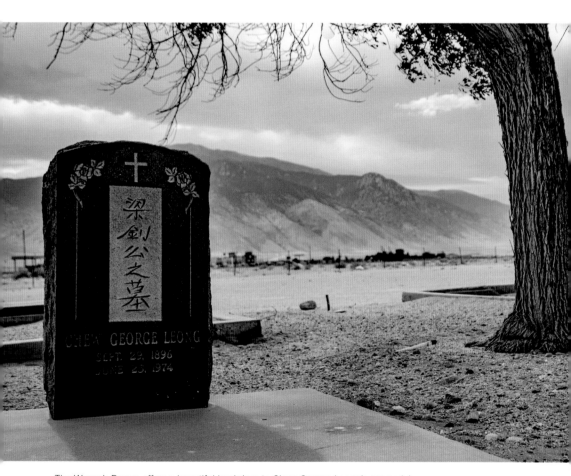

The Wassuk Range offers a beautiful backdrop to Chew George Leong's memorial.

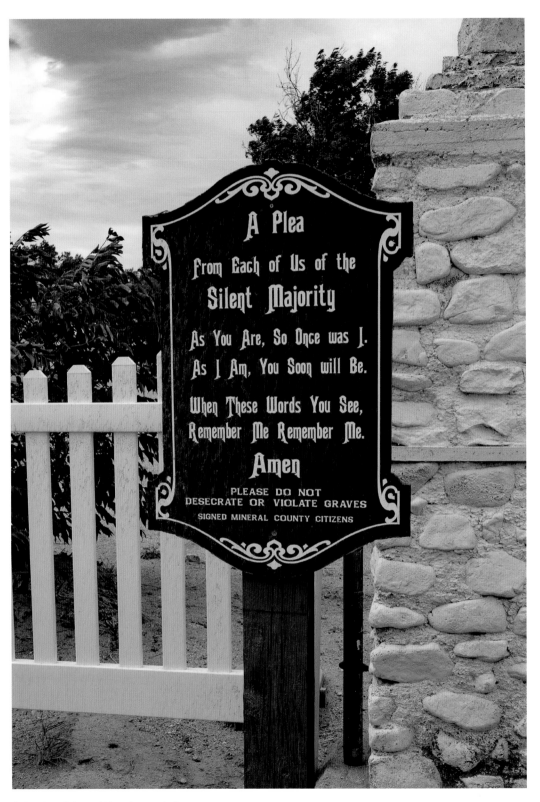

A sign found at most Nevada cemeteries.

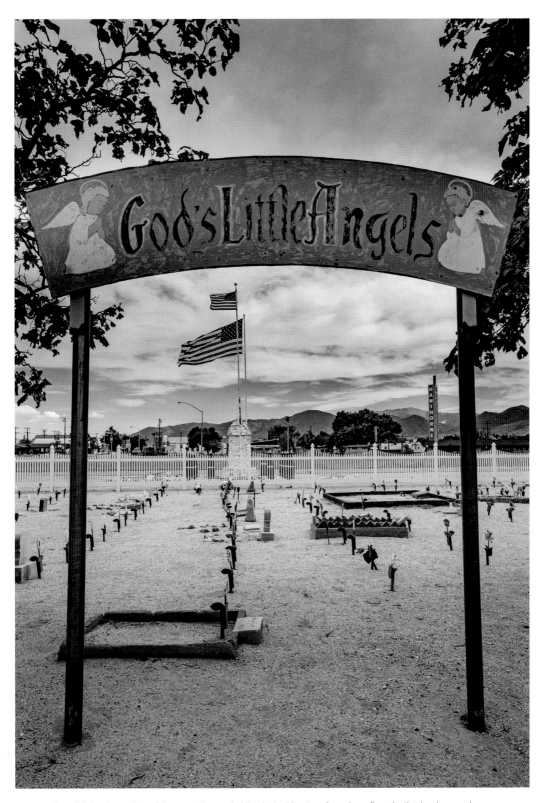

The children's section of the cemetery; a brisk wind whips two American flags in the background.

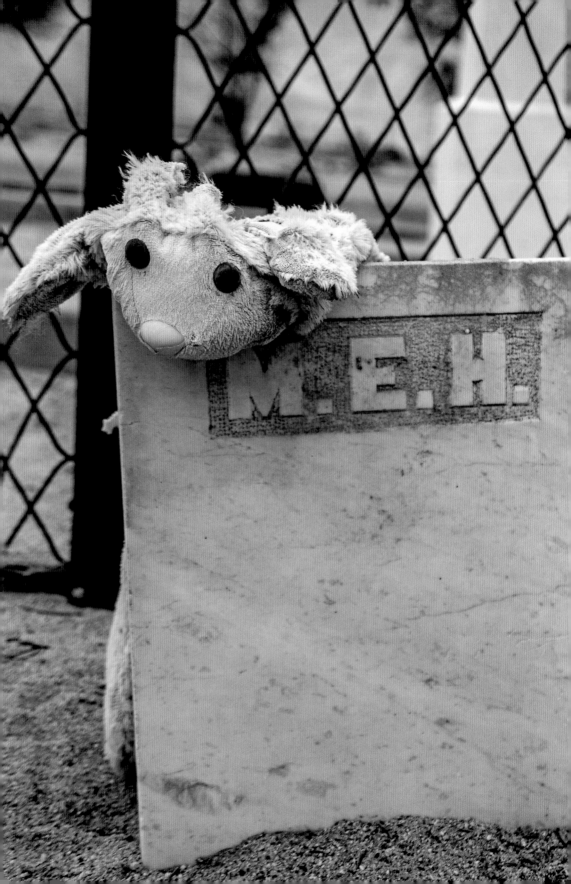

A discarded teddy bear once adorned a child's grave.

A little angel watches over a baby's grave in the "God's Little Angels" section.

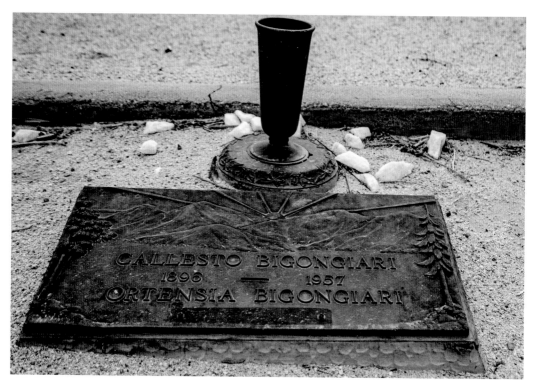

Natives of Italy, the Bigongiaris became residents of Hawthorne in 1936.

Nevada Senator (1927–1941) John Harvey Miller has a unique grave marker.

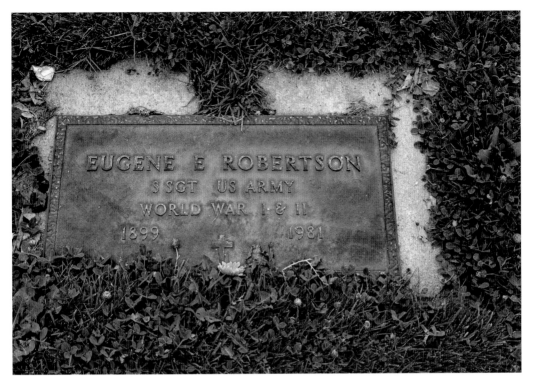

Eugene Robertson was a veteran and popular baseball player in the 1920s.

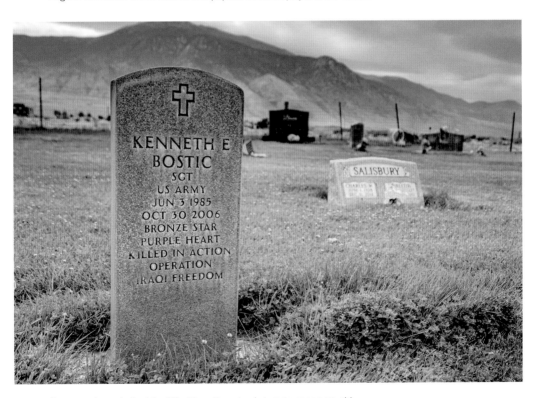

A young, decorated soldier killed in action at only twenty-one years old.

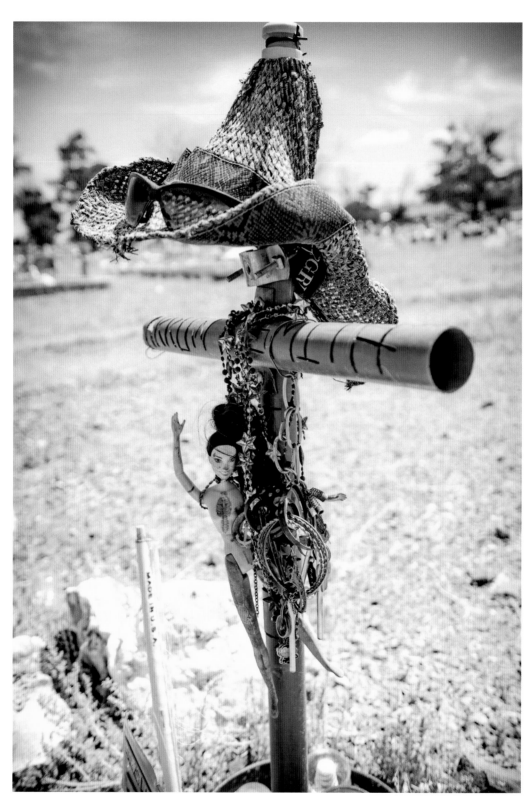

Miscellaneous memorabilia left for Eric A. Arrowsmith.

MINA CEMETERY
ESTABLISHED EARLY 1900s

The clickety sound of the southbound freight
And the high-speed hum of a passenger train
Becomes a part of the soul and a heart and the mind
Of a boy who's raised by the railroad line.

~Chris LeDoux, "Raised by the Railroad"

Ransom Riggs, best-selling author of *Miss Peregrine's Home for Peculiar Children* (published 2011) visited the town of Mina, Nevada, in 2009, and published an article about his experience called "Desolation Vacation: Mina, Nevada." He explained the area this way:

> There are many ghost and near-ghost towns in Mineral County—a county that boasts just 5,071 residents, or about one per square mile. Two-hundred-sixty-one of those people live in Mina, a town named for a railroad executive's daughter one hundred years ago, which in Spanish means "ore." The railroad and mining operations are long gone, and from the looks of things, at least half the town sits abandoned. Best known for a 1921 murder scandal that resulted in the world's first execution by lethal gas, today Mina is a perfect example of a desert town on its way out.

Mina remains largely abandoned, and the population has fluctuated: in 2015, twenty-four people lived there, and in 2020, the town topped out at 105 residents. While it was founded as a station for the Nevada & California Railway, Mina was also a successful mining town. According to the Bureau of Land Management, Mina (and the surrounding area) includes 40,145 mines with more than 7,000 claims still active.

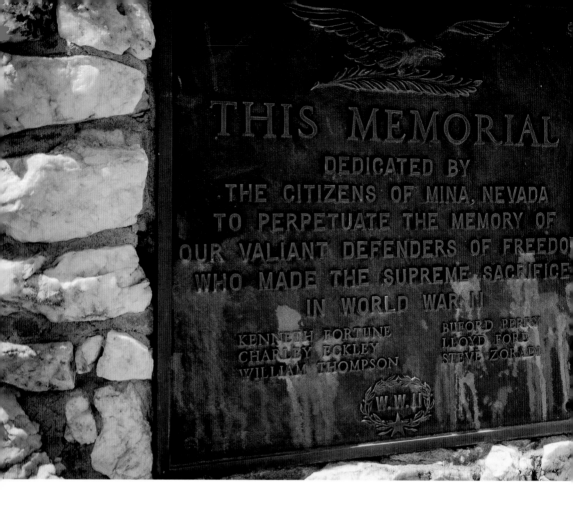

THIS MEMORIAL

DEDICATED BY
THE CITIZENS OF MINA, NEVADA
TO PERPETUATE THE MEMORY OF
OUR VALIANT DEFENDERS OF FREEDOM
WHO MADE THE SUPREME SACRIFICE
IN WORLD WAR II

KENNETH FORTUNE BUFORD PERRY
CHARLEY ECKLEY LLOYD FORD
WILLIAM THOMPSON STEVE ZORADI

W.W.II

The Mina Cemetery has 512 recorded memorials though not all the graves are marked, including Chinese immigrant Tom Quong Kee, the victim of the "1921 murder scandal" mentioned by Riggs. Gee Jon and Hughie Sing, members of a gang that originated in San Francisco called the Hop Sing Tong, shot Tom Quong Kee, a laundry man in Mina, through the heart, probably because Kee was part of a rival tong. Jon and Sing were convicted of murder; Jon, who pulled the trigger, was sentenced to death while Sing would serve life in prison. Gee Jon gained fame as the first person in the world to be executed by lethal gas. The sentence was carried out at the Nevada State Prison in Carson City, and Jon is interred in the prison's burial ground.

Much of the graveyard includes plain white wooden crosses, some next to more formal marble or military grave markers while many are simply lined up in rows without any indication of who lies beneath.

Many veterans are laid to rest in the cemetery, and they are appropriately honored with small American flags and ribbons on their graves. Sergeant Anthony Elffner

(1867–1948) served in the Spanish-American War while numerous others served in World War I and II, the Korean War, and Vietnam. It is relatively rare to find graves of female veterans in most Wild West cemeteries, but Mina hosts two: Mary G. Brooks was a sergeant in the Army during World War II; Blanche A. Edison was a Hospital Apprentice 1 with the Navy during World War II.

Even with the town relatively abandoned, the graveyard is fairly manicured. There may be some desert weeds threatening to reclaim the area, but the graves themselves are clean, and many of them are decorated with colorful silk flowers.

While journeying along U.S. Route 95, a traveler should stop at Socorro's Burger Hut (incidentally, the only location tagged by Google maps for Mina) for pleasant company, a clean bathroom (with food purchase), a tasty milkshake, hot fries or a bag of chips, and a juicy burger. Make sure to take cash because the owners don't take credit cards.

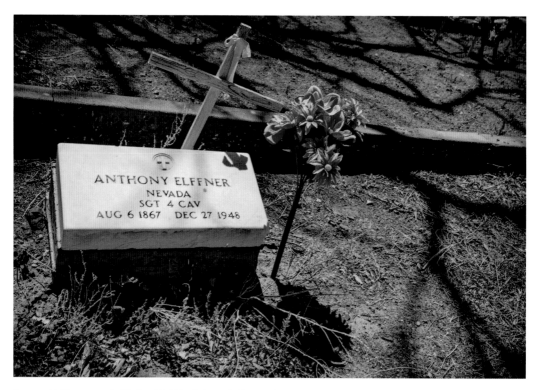

Sergeant Elffner served with the 4th U.S. Calvary during the Spanish-American War.

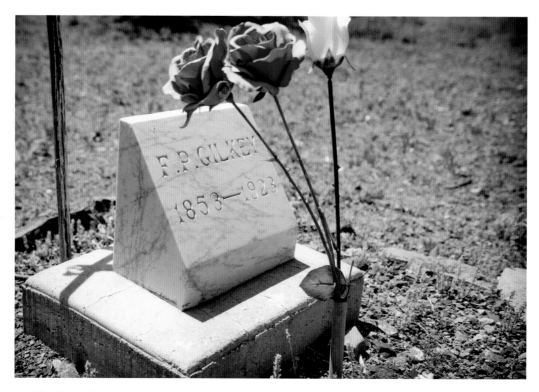

Franklin Pierce Gilkey, named for the fourteenth U.S. president.

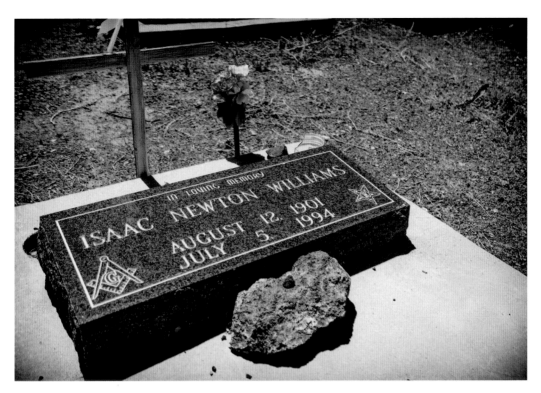

Isaac Newton Williams, named for famed physicist, mathematician, and a fellow Freemason, Isaac Newton.

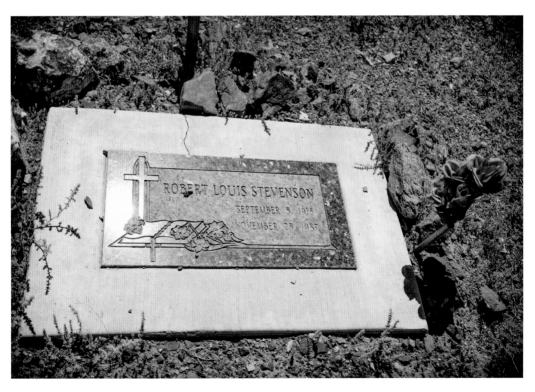

Robert Louis Stevenson, named for the *Treasure Island* author of the same name.

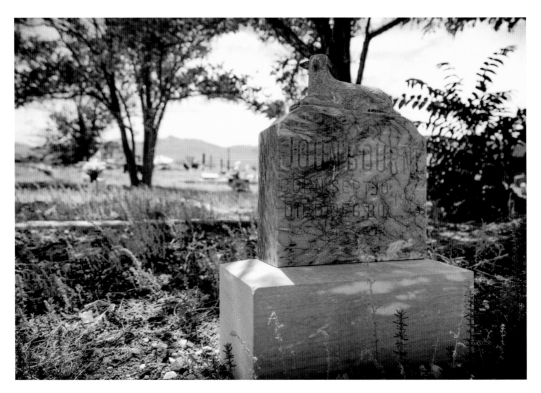

John Bourne lived only three months.

A wooden cross with indecipherable writing.

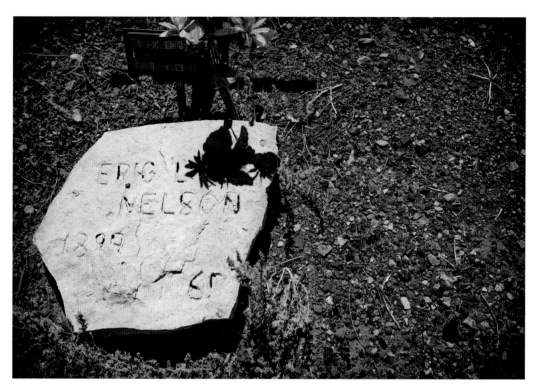

Eric L. Nelson (1899–1965).

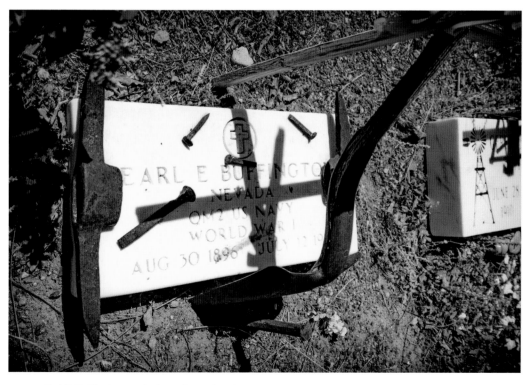

Earl E. Buffington was both a sailor and a miner.

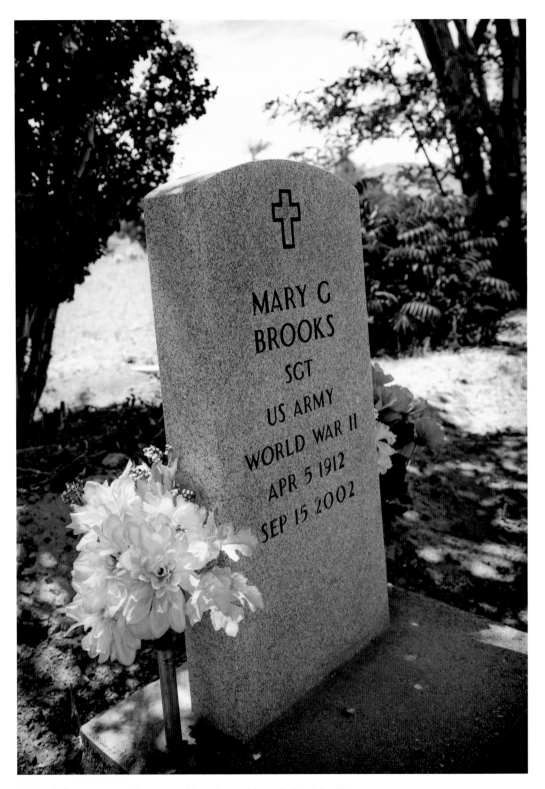

Bright silk flowers contrast the grey marble of Sergeant Mary G. Brooks' military grave.

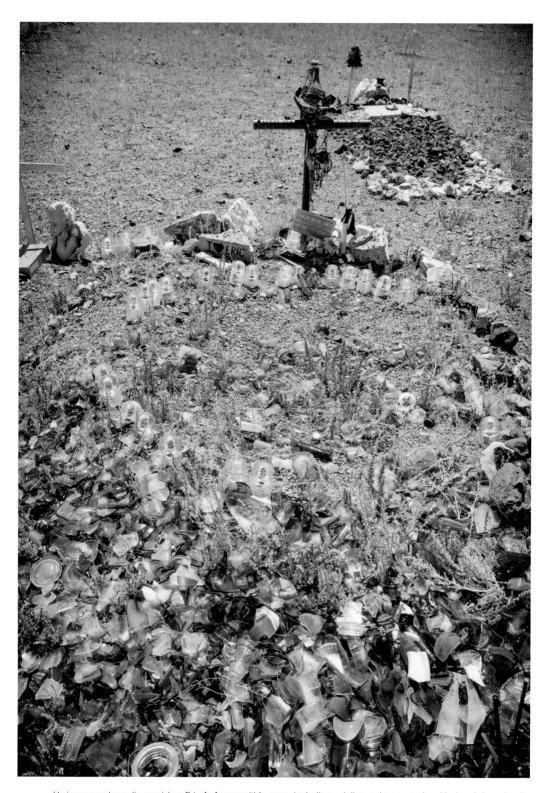

Various paraphernalia garnishes Eric A. Arrowsmith's grave, including a doll, sunglasses, and multicolored glass shards.

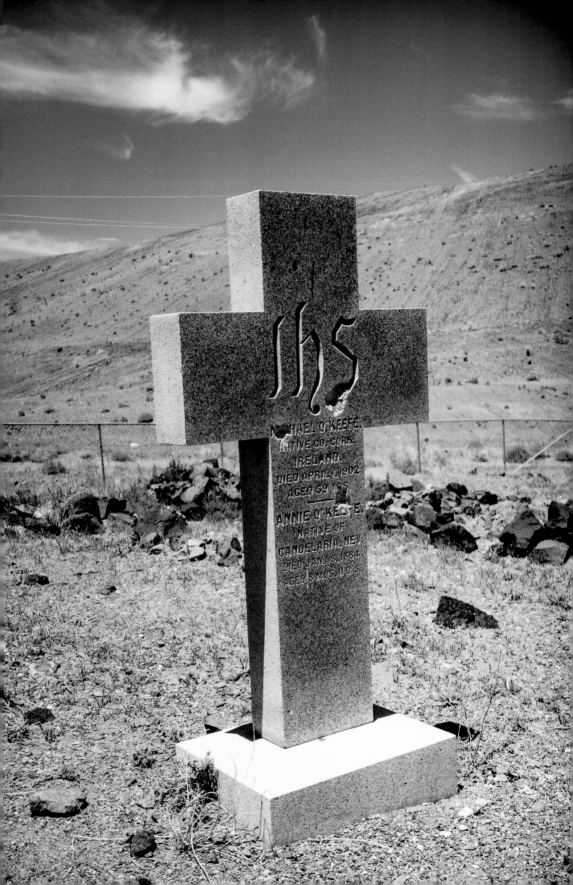

CANDELARIA CEMETERY

ESTABLISHED EARLY 1870s

Precious metal is hard to find
Down in the hole
And down in the mine
I dig my life away

~Woody Guthrie, "Miner's Song"

C andelaria is a *bona fide* ghost town that sits seven miles to the west of U.S. Route 95. The state historical marker—complete with one bullet hole—off the highway explains there are actually two ghost towns: Candelaria and Metallic City, but only the ruins of Candelaria remain. The sign describes the once-vibrant mining area:

> Candelaria was presumably named after a mine of that name … and also after the Catholic Candelmas [*sic*] Day. Metallic City, the "sin city" of Candelaria, and also known as Pickhandle Gulch, lies 3/4 mile to the south [of] Candelaria. The name, Pickhandle, was derived from the most popular weapon used for settling disputes. In 1880, Candelaria was the largest town in the immediate area and boasted having 3 doctors, 3 lawyers, 2 hotels, 6 stores, and 10 saloons…. The leading mine the Northern Belle was first located in 1864 (relocated in 1870). It is reported to have produced an estimated $7 million, mainly in silver [other sources say the mine produced upwards of $15 million worth of silver].

Because of Candelaria's unfortunate location in the middle of the barren Nevada desert, its residents took to drinking whiskey instead of water, which was scarce and

expensive. The Only in Your State website suggests that "Any town where whiskey is easier to get than water is going to be rough. Fires, robberies, shootings, and murder were all common occurrences." In addition, the lack of easily accessible water meant the mining in the area was done using a waterless mining technique (called "dry stamping"). Such a method caused excessive cases of "miner's consumption," a respiratory disease caused by the fine dust created during the process. In 1882, dry conditions were remedied by the development of a railroad depot, so water could be easily imported in bulk. The town flourished for ten years until a financial panic in 1893 began Candelaria's demise, and it would never recover. The post office finally closed in 1939, and the last citizens had deserted the area by 1941. Along with some scant ruins of the abandoned town, the Candelaria Cemetery remains in the shadow of a mine. Find A Grave lists 121 memorials, but fewer than twenty have any indication of who is buried there. The names demonstrate

the diversity of a mining community. While Mexican prospectors discovered and named the area Candelaria (or Candalaria) in 1864, it was German and Slovakian miners who established the camp that would become a boomtown in 1879; the Spanish name stuck, however.

The graveyard includes Mexican, Irish, Canadian, German, Italian, and Eastern European immigrants whose causes of death range from illness to mining accidents to murder to old age. Samuel L. Gaunce (died at age thirty-three of pneumonia in 1884) hailed from Nova Scotia and, according to the etching on his tombstone, was a member of the Ancient Order of United Workman, a fraternal organization active in both the United States and Canada. Italian natives Anna Molini (1849–1902) and her husband Emanuel Molini (1848–1919) are buried next to each other in a family plot surrounded by an iron fence. Their white granite crosses are dusty but otherwise undisturbed.

Of the few other stones, many have been broken or shot at. A native of Ireland, Michael O'Keefe (1843(?)–1902) and his infant daughter Annie (1883–1884) have a large granite cross as a marker with three large bullet holes skewing the information on it.

Joseph "Black Joe" Berwick, born in Ireland, has no marker, but his demise encompasses a typical Wild West life and death. An excerpt from the Candelaria *True Fissure* (the local newspaper from 1880–1886) explains that he was "Assassinated … by Dick McEwen after a dispute involving a bet in a poker game…. Black Joe was a man not popular, but his untimely death brought out the better feeling of the people and many expressions of sympathy and condolence were made for him and his grief-stricken wife…. McEwen was not charged in the murder allegation." Anna Marguerite Chiatovich (1895–1902) and Clarence Meginness (1881–1902) share a tall, square dark-grey marble memorial that once stood on a marble base bearing their last names. Tragically, the marker has been pushed off its base and now lies in the Nevada dirt. Anna Marguerite Chiatovich was a member of the Chiatovich Clan, begun by Margaret and John Chiatovich (Anna's parents) who settled in Lander County (east of U.S. Route 95, part of northeastern Nevada) in the 1860s. According to Croatia.org, the editor of *True Fissure* recognized John as being "one of the Slavonian pioneer locators in Landers [*sic*] County in the early 1860s. The Slavonians [who were from former Yugoslavia and would now be called Croatians] were the first Europeans of that area…. He operated a lumber business in Candelaria in the 1880s and had a store and hotel at Silver Peak in 1876." John and many others of the Chiatovich Clan are buried in Silver Peak Cemetery, Esmeralda County, Nevada. Clarence Meginniss, the name adjacent to Anna's, was probably a child of Margaret's from her first marriage to James Madison Meginniss though details are vague on that point.

Candelaria is 272 miles north of Las Vegas and 180 miles south of Reno. It is a terrific historical attraction on your way to or from the glitter and glamor of towns whose sparkle comes not from silver but from neon and electric lights.

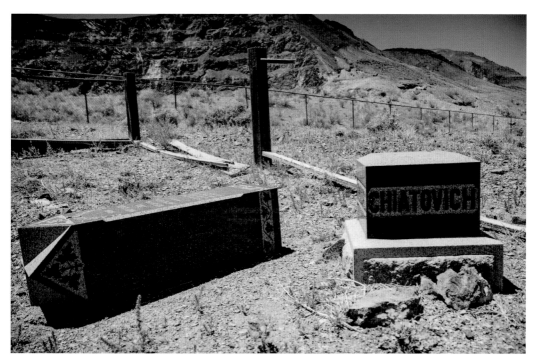

Seven-year-old Anna Marguerite Chiatovich's displaced grave marker.

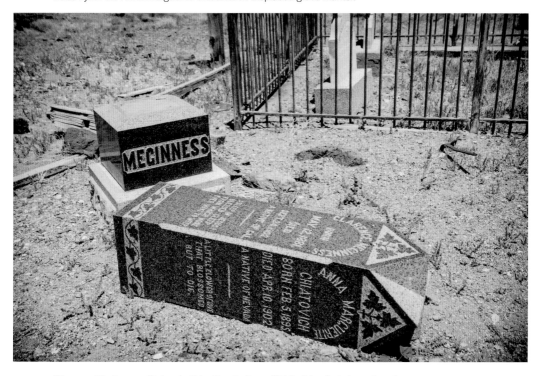

Clarence Meginness, likely a half-brother to Anna Chiatovich, died at age twenty-one.

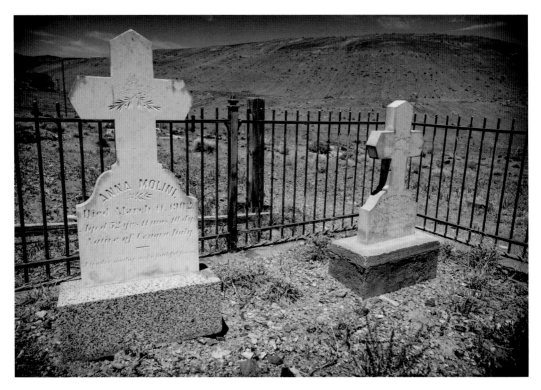

Anna and Emanuel Molini, natives of Genova, Italy, ended their days in Candelaria.

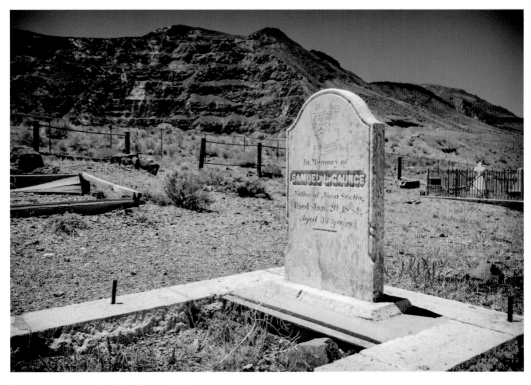

Pneumonia claimed the life of Samuel L. Gaunce.

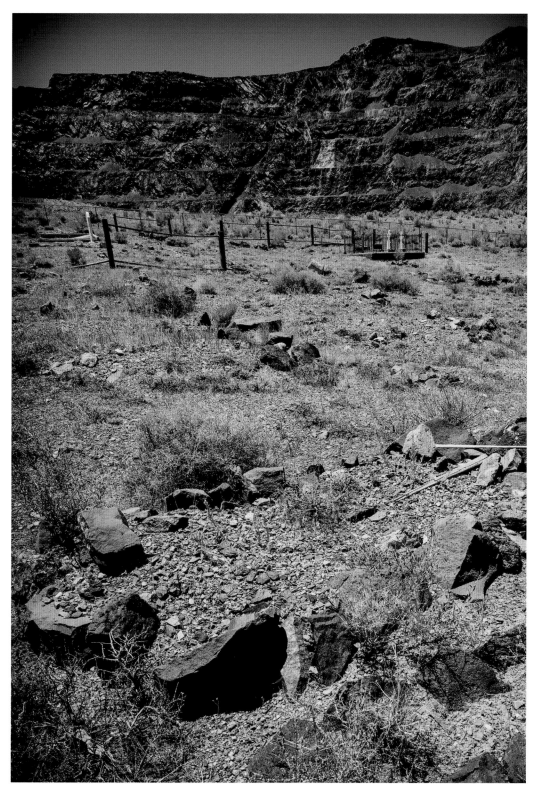

Unknown graves in the foreground; Candelaria's mine in the background.

SILVER PEAK CEMETERY,
ESTABLISHED 1860s

And I feel like I'm dying,
From mining for gold
Yes, I feel like I'm dying,
From mining for gold.
~Cowboy Junkies, "Mining for Gold"

Silver Peak is one of the oldest mining areas in Nevada, and it continues to rely primarily on mining to stay afloat today. Gold, silver, and other minerals were mined starting in 1863. The town never boomed, resulting in a population fluctuation over the years until Silver Peak burned down in 1948. It should have become a true ghost town after that, but in 1966, the Foote Mineral Company started extracting lithium in nearby Clayton Valley.

The Silver Peak lithium mine, currently owned by Albemarle, is North America's only lithium brine operation and employs many residents from the town of approximately one hundred people. Lithium brine extraction occurs when salt brine deposits are located underground; the brine is pumped to an evaporation pond; once the liquid has evaporated, the brine is pumped to a lithium recovery facility for extraction. The whole operation can take months or years.

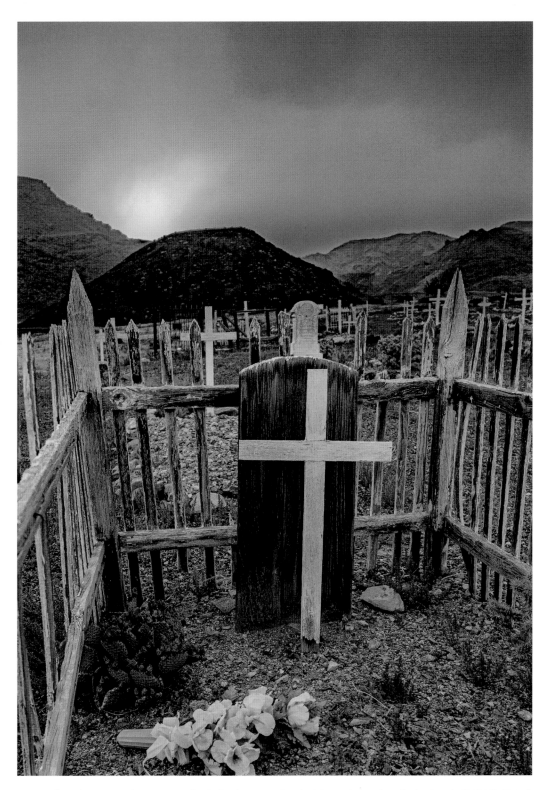

An unknown wooden grave marker in the foreground; a duststorm at sunset on the horizon in the background.

The demand for lithium has recently increased. It is used for many reasons, but, perhaps most importantly, in rechargeable batteries for electric vehicles, mobile phones, and other consumer electronics. Aluminum-lithium alloys are used in aircraft, bicycle frames, and trains. Lithium carbonate is used in medication to treat manic depression.

Along with lithium, Clayton Valley is home to another natural phenomenon: a 365-foot-high cinder cone (an extinct volcano), which is best viewed from the abandoned town of Blair, three miles north and a 300-foot climb from Silver Peak.

The city of Silver Peak is a tiny oasis surrounded by a mountain range, lithium fields, and lots of desert. The town has a library, fire department, community center, and one bar (Old School Bar). It also has a cemetery bordered by the foothills of the Silver Peak Range to the west and the actual town in the other directions.

The cemetery is small—Find A Grave documents only ninety-four memorials. Four families dominate the graveyard: Chiatovich, Cleary, Shirley, and Vollmar.

John Chiatovich was born in former Yugoslavia (now Croatia) and immigrated to the United States around 1856. Find A Grave offers details about this Nevada patriarch:

> He operated a lumber business in Candelaria in the 1880s and had a store and hotel in Silver Peak in 1876. He was a member of the Lida Valley Esmeralda Fire Company One. He was a pioneer of Virginia City and Silver Peak, Nevada. He began the Chiatovich Ranch and Store in Fish Valley, Silver Peak, Nevada. Besides the other businesses he ran, he was also a miner.

John, his children (except Anna, who is buried in Candelaria), and grandchildren also occupy the cemetery, all of whom have well-manicured granite or marble markers. John's wife, Margaret, outlived him by twenty-nine years, dying in Reno; she is buried at Mountain View Cemetery.

John Declan Cleary, Sr., was born in Canada, moved to California then Nevada and back to California after the death of his wife Katherine in 1913. Find A Grave indicates he died in San Francisco in 1918. His body was returned to Nevada, and he was laid next to Katherine. Seven of John and Katherine's children were alive when he was interred. All seven are now buried near their parents. John and Katherine have boothill-style wooden markers while the children's are marble.

Anna and John Shirley, their three children, and their grandson all rest together in the cemetery.

The Vollmar family patriarch, Fred, came from Wisconsin to Nevada by way of California. Along with his headstone, an elaborate once-pristine-now-cracked tablet (which may have been vertical at some point but presently lies on the ground) reads as follows:

Erected by Fred Vollmar and Mrs. H C Cameron in Loving Memory of Their Father Fred A Vollmar. Born in Wisconsin. Emigrated to California(?), studied chemistry under Abbot Hanks, came to Nevada gold fields in 1880, worked in English Mills near Virginia City. Erected custom mill near Lida, came to Silver Peak in 1898 to take charge of the Chiatovich mill[;] located here permanently in 1901, was one of the first to use the cyanide process [to extract gold from the surrounding rock] successfully. Lost two sons in the World War, Adolph and Harry Vollmar, 1918.

Fred's sons and his wife Molly, along with two other children who died young—William (1897–1906) and Lucy (1892–1905)—are buried near him.

While Silver Peak used to be located along a dirt road, in June 2020, Cypress Development Corporation paved the road to allow better access to another nearby lithium field being developed by the Clayton Valley Lithium Project. Because the town is nestled in the Great Salt Basin, a flat land, it is prone to dust storms in the summer, so travel with caution and maybe take cover in the Old School Bar.

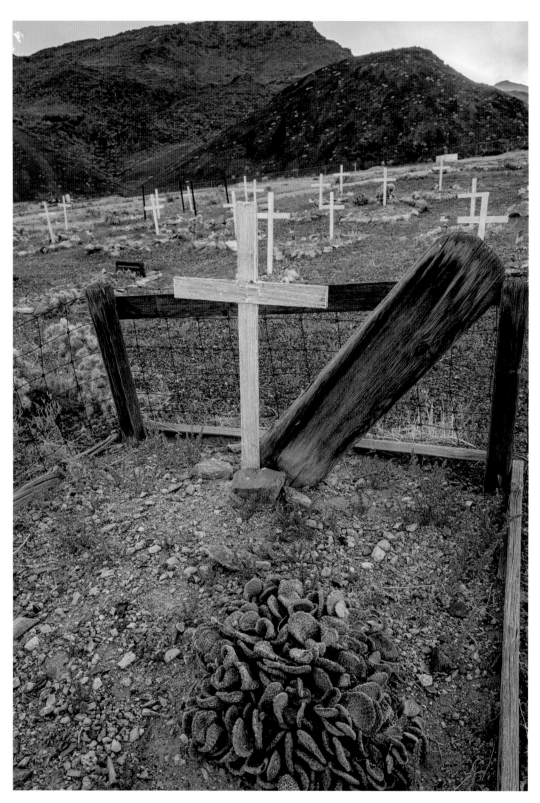

An unknown grave with only a Plains prickly pear for decoration.

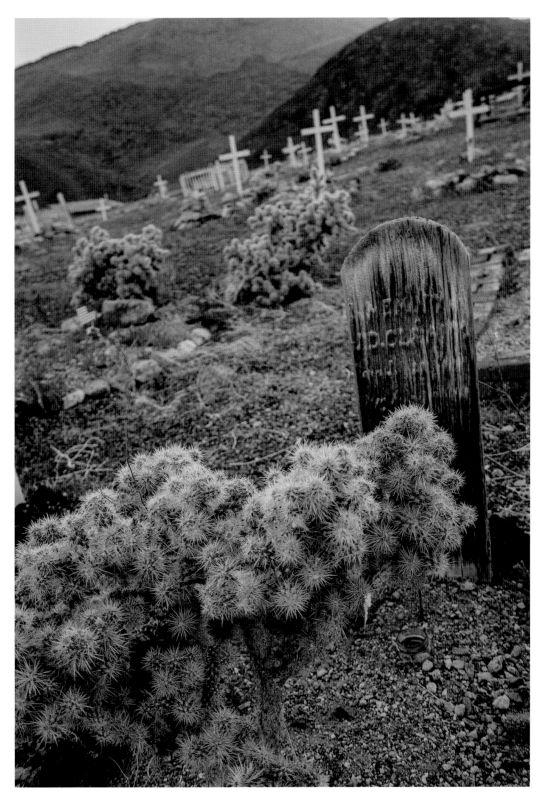

A faded inscription on a boothill-style grave marker. Silver cholla in the fore- and background.

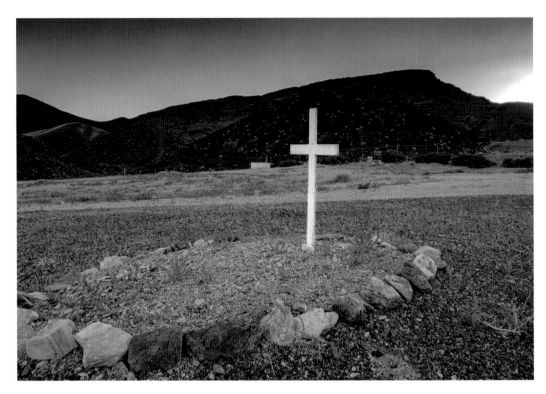

A lone unknown grave in the shadow of the mine.

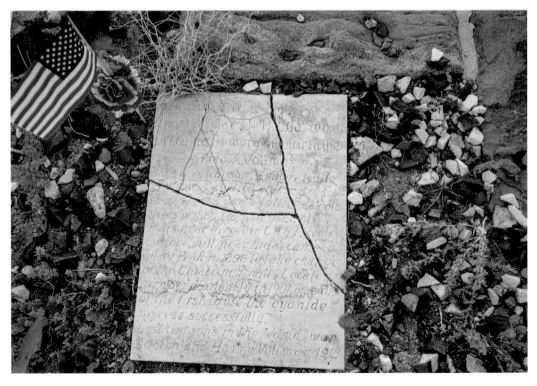

Fred Vollmer's toppled and broken grave marker.

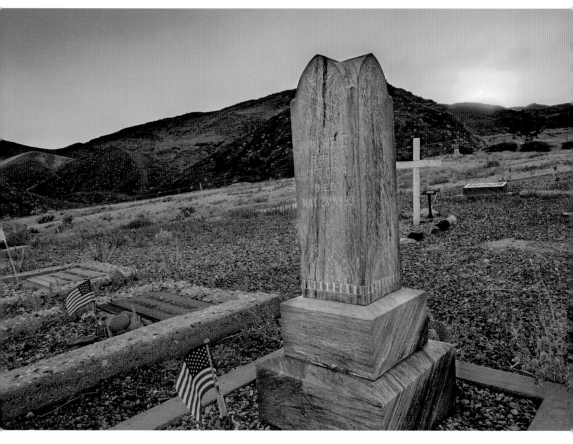

The Shirley family plot.

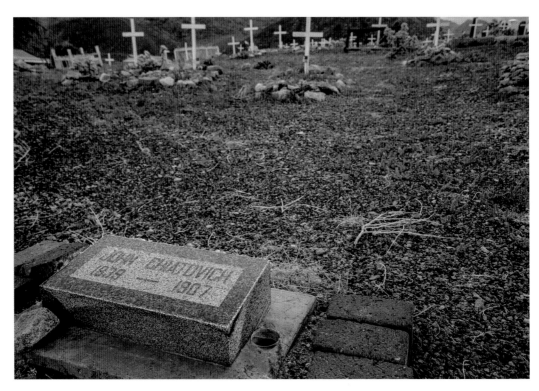

The patriarch of the Chiatovich clan.

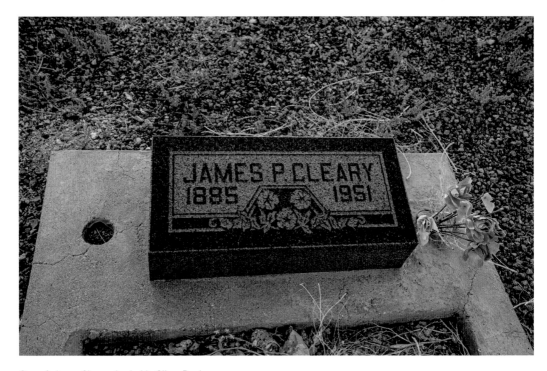

One of eleven Clearys buried in Silver Peak.

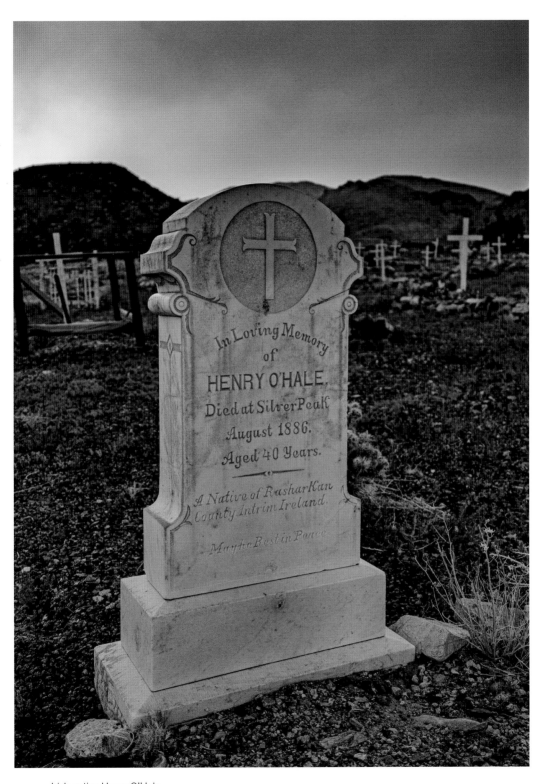

Irish native Henry O'Hale.

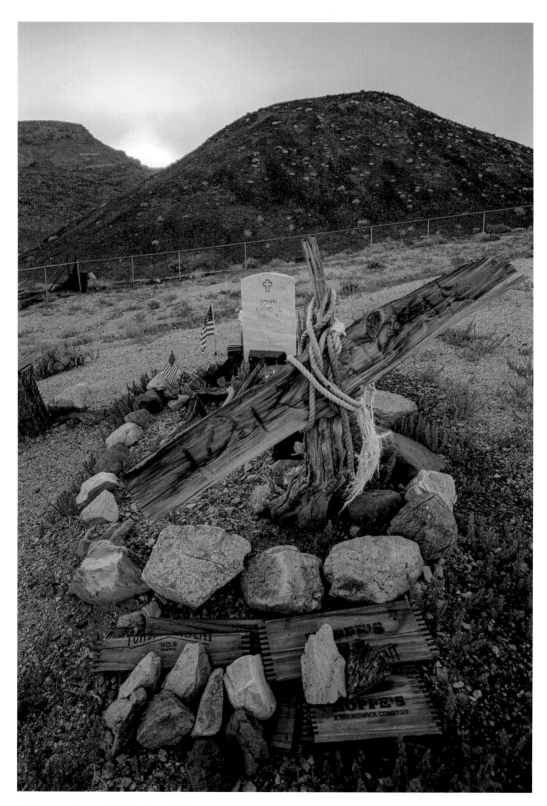

Various accoutrements bedeck a soldier's grave.

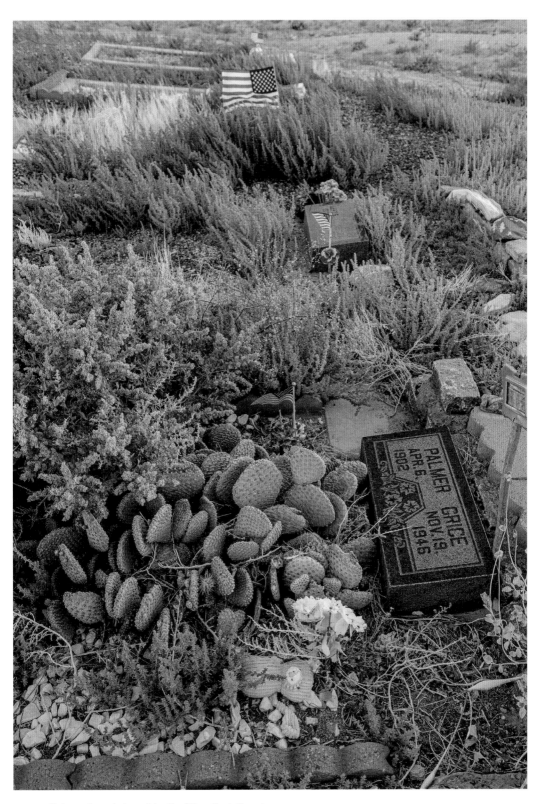

Nature attempts to reclaim the Silver Peak Cemetery.

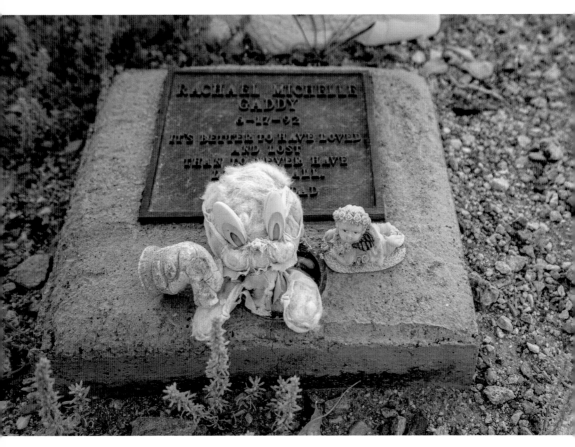

A deteriorating plush toy on an infant's grave.

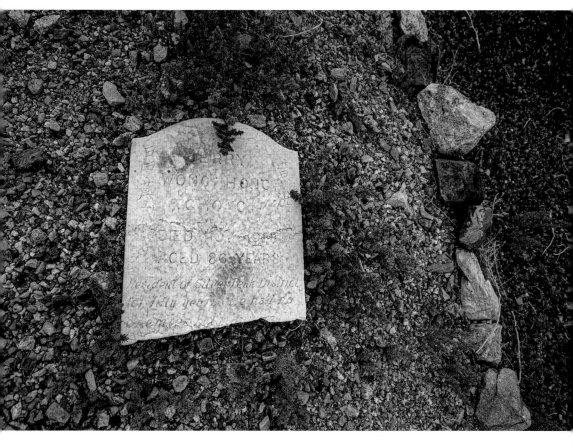

Jerry Wong Hong Chong's inscription reads, "Resident of Silver Peak for fifty years. He had no enemies but many creditors."

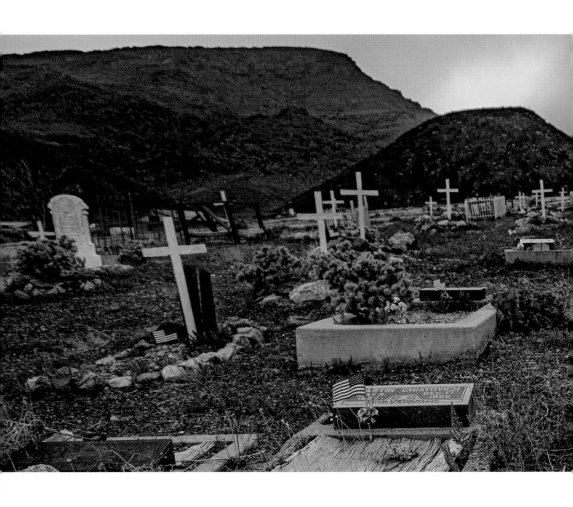

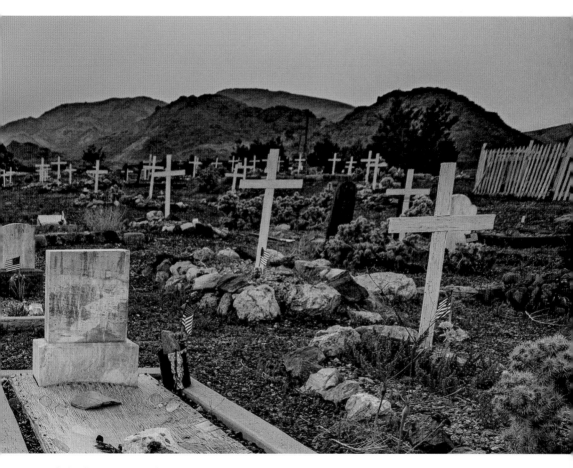

A dazzling panorama of Silver Peak Cemetery.

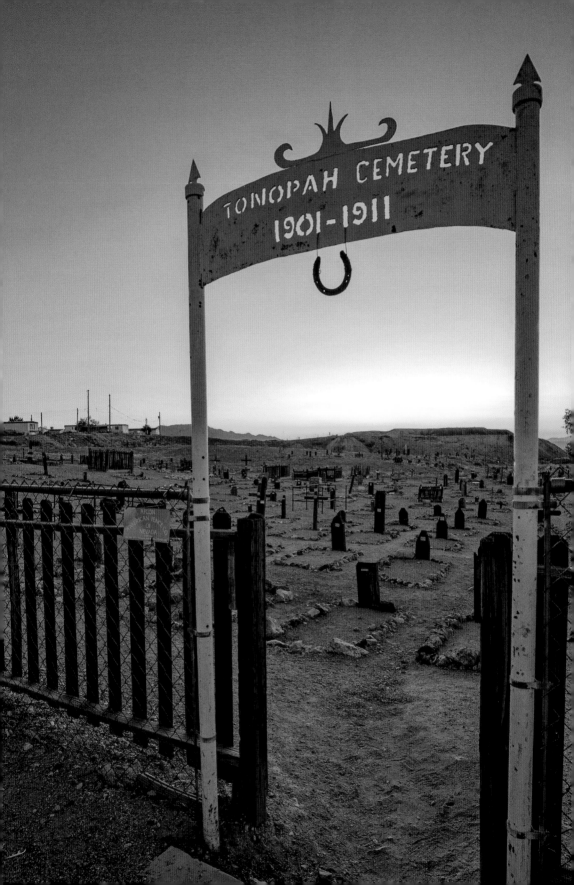

FIRST TONOPAH CEMETERY
(AKA OLD TONOPAH CEMETERY), EST./IN USE 1901-1911

"Buried here are many of Tonopah's pioneer residents,
including victims of the Tonopah-Belmont Mine Fire of Feb. 23, 1911,
as well as the victims of the 1902 'Tonopah Plague.' Cemetery fenced
1979 by Central Nevada Historical Society."

~Entrance to Tonopah Cemetery

The founding of Tonopah, called Tonopah Springs from 1900–1905, involves an ornery burro, an outcropping heavily laced with silver, and two colorful characters: Jim Butler and Tasker Oddie. At least the story of the wayward burro, owned by Butler, who chased the critter to the famed outcropping, is the most popular. Tasker Oddie, who would become the twelfth governor of Nevada and a United States' Senator, came in later.

Butler's samples from Tonopah Springs were rejected by the first assayer he took them to. It was Tasker Oddie, while visiting Butler, who offered to pay for a second assay; Butler agreed. Assayer William Gayhart estimated the ore at $600 a ton. In August 1900, Butler and his wife filed eight claims, six of which—Desert Queen, Burro, Valley View, Silver Top, Buckboard, and Mizpah—ended up being some of the biggest ore producers Nevada has ever had.

Tonopah was most successful between 1900–1921, and the ore produced in the mines was worth nearly $121 million. The town never recovered from the Great

Depression, and Tonopah nearly became a ghost town in 1947 when the railroad that ran through it shut down.

Now, Tonopah relies on its history and tourism to survive. (As an aside: it also boasts the only gas stations within 182 miles. Between Delamar and Tonopah, along the Extraterrestrial Highway (State Route 395), is the tiny town of Rachel, which is famous for having an entrance to Area 51 (but no gas station) and infamous as the meeting place for the unsuccessful Facebook event of September 2019 called "Storm Area 51." The blockbuster movie *Independence Day* (1996) was also filmed in the area and the production company left a memento at the Little A'le'Inn, a motel, restaurant, and tourist stop for all things UFO-related.)

One of the touted tourist attractions is the Old Tonopah Cemetery. Popular travel site *Atlas Obscura* claims, "There's nothing creepier than a cemetery next to a clown motel." *Atlas Obscura* is not wrong. The cemetery is distressing enough, but its adjacent location to the "World Famous Clown Motel" is unsettling. *Atlas Obscura* says this about that stretch of Main Street: "While Nevada's Clown Motel may seem like the product of a horror writer's fevered imagination with its army of glassy-eyed clown dolls and convenient proximity to a Wild West cemetery that holds the (possibly unquiet) remains of local miners, the dusty little lodging is just a fan of merriment. They swear."

Whether or not the cemetery is haunted by miners remains to be seen. What is haunting are the remnants of the mine—which can be seen to the west of the cemetery—that sent some of the miners to their deaths. Its oppressive presence lords over their final resting place. Outside the entrance to the cemetery and Clown Motel, near the street, stands a memorial "In Memory of the Miners of Central Nevada," complete with a rusty ore cart and tracks sitting atop the concrete structure. The plaque lists 108 men and explains, "This monument is dedicated to the memory of those miners who lost their lives working in the silver mines of Tonopah and Belmont, Nye County, Nevada. These men paid the ultimate price that contributed to the economic success of this prosperous and thriving mining community during the first half of the twentieth century."

Within the cemetery itself, about 300 people are buried, according to *The Walking Tour* map provided by the Town of Tonopah (Find A Grave lists 470 memorials, but

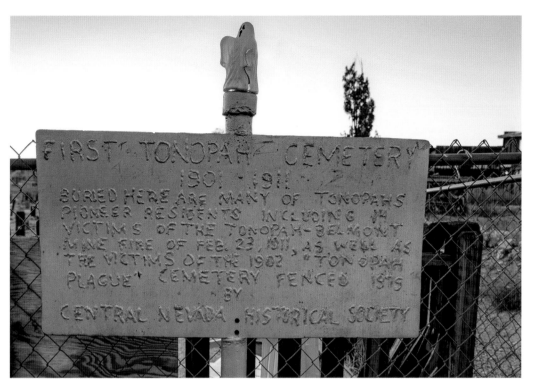

The ghost on top of the informational sign may not be the only one haunting the cemetery.

The Murton brothers all died young in Tonopah.

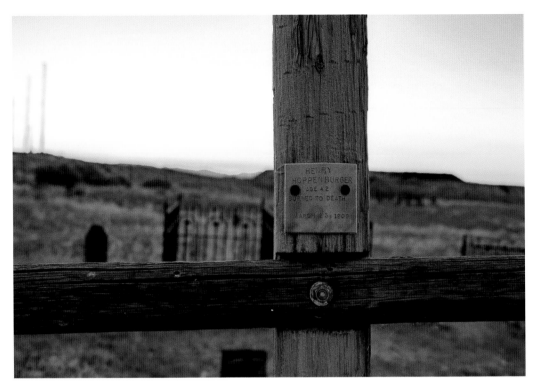

Henry Hoppenburger died in a mining accident.

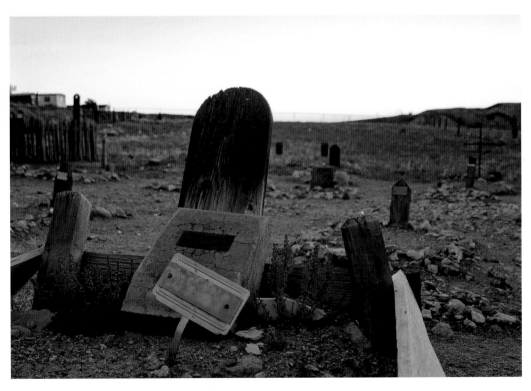

Thomas Gillam's cause of death reads only as "blood poison."

there may be confusion with the New Tonopah Cemetery, which was established in 1911; due to overcrowding of the old cemetery, some of the bodies were moved there). The Central Nevada Historical Society has done a marvelous job commemorating the graves in the cemetery with small tin plates bolted into the hundreds of wooden markers. There are also some traditional marble and granite tombstones.

Mining accidents were common. Brothers Felemir (twenty-eight years old) and George (twenty-two years old) Marojevech from Montenegro (part of former Yugoslavia) were killed in an ore car accident. Henry Hoppenburger burned to death in a mine accident in 1909. Seventeen miners were killed in the Tonopah-Belmont mine fire; after the disaster, many of the victims were interred in the graveyard. The hero of the day was William F. "Big Bill" Murphy (twenty-eight years old), who was the cage operator at the mine. When the fire started, miners began ascending in the cage; once they reached the surface, no one wanted to descend with the cage back into the fiery mine shaft. No one except Big Bill. He made two successful runs down the shaft, rescuing confused and unconscious miners. He made a third descent but did not return; he rests now with his fellow miners who could not be saved.

Tragedy struck in other ways, too. Some grave markers read simply "Life became a burden," implying the person buried there committed suicide. The Murton brothers are buried together in a family plot surrounded by an iron fence. *The Walking Tour* pamphlet describes their deaths (spelling their names as "Merten" while their grave markers read "Murton"): "The three Merten brothers all died between September 1908 and July of 1910. First, Albert Merten died of typhoid fever. Next, Sam Merten was killed in an accident in the Montana Tonopah Mine. William Merten was the last to die. At only seventeen years of age, he died of heart failure."

In 1902, many of Tonopah's pioneer residents fell victim to the mysterious "Tonopah Plague." Find A Grave states that "it has never been determined what the 'Tonopah Plague' was … but it claimed the lives of over 30 men and caused a mass exodus from the area."

In 1906, pneumonia struck down numerous Tonopah citizens. Jaundice, diphtheria, consumption (tuberculosis), and typhoid fever also claimed victims now laid to rest in the graveyard. There is also a large infant section since childbirth was as dangerous as mining. One small wooden marker's tin plate reads "Back F Una and two babies May they rest in peace"; Find A Grave says the true name of

the person with the two babies is Hannah Buckland. Numerous other graves simply say "Infant" and the family's last name.

Although the cemetery was closed to burials in 1911 due to the lack of room, Norman N. "Curly" Coombs was buried there in 1996 at the age of eighty-two. His granite marker indicates he was in World War II and was affectionately known as a "tramp miner," which means, "he drifted from one mining job to another, in the process sometimes acquiring great knowledge about mining techniques and the occurrence of minerals—in Norman's case, especially gold."

One of the old cemetery's famous graves is Bina Verrault (birthdate unknown–1907). *The Walking Tour* pamphlet explains that she was a woman running from the law when she ended up in Tonopah, Nevada. She and her friend, Izella Browne ran a "Love Syndicate [in New York City]. The women claimed to be wealthy widows" who would "seduce rich men into giving them expensive gifts and money. One man fell in love with Bina. When she refused his attentions and did not return his gifts, he went to the authorities." Bina was arrested; at the time of her arrest, it was estimated that she and Browne had collected about $100,000 (about $2.5 million today) in money, clothes, and jewelry. Bina escaped her trial and died in Tonopah a year later from heart failure probably related to alcoholism.

Tonopah is a fascinating town rich with history. Much of that history can be discovered at the admission-free Central Nevada Museum. The Tonopah Historic Mining Park is located on the site of the original mining claims that created the boomtown; you may take a self-guided walking tour, which includes not a grave but a shack that housed another famous femme fatale who visited Tonopah while on the run: Barbara "The Butcher of Burbank" Graham. Graham was eventually caught, convicted of murdering an elderly widow, and executed at San Quentin Prison in California.

Both TonopahNevada.com and AtlasObscura.com offer additional attractions. Keep in mind, though, when you see a sign that says, "Next gas 150 miles," take it seriously and stop for gas (or you can try trusting in the aliens to get you to Tonopah safely, which actually worked for this adventuring duo, but we don't recommend it).

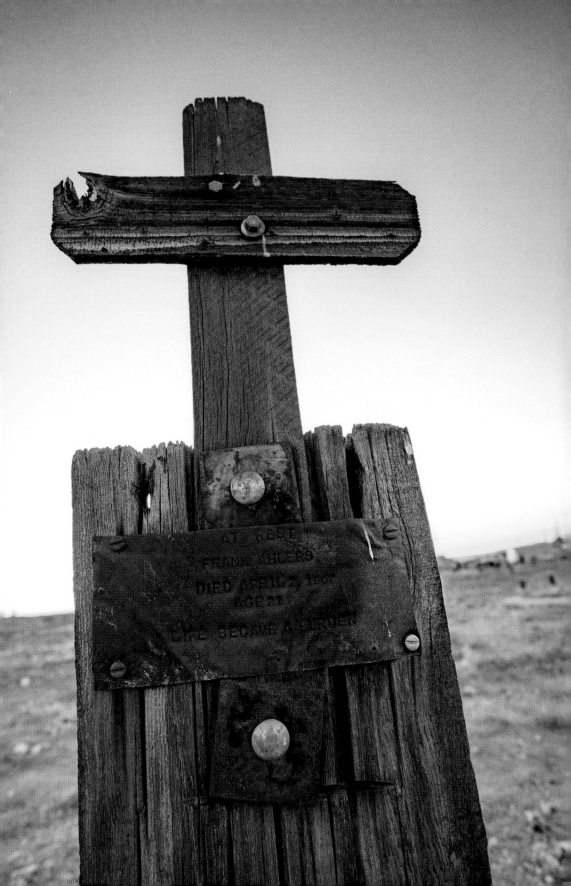

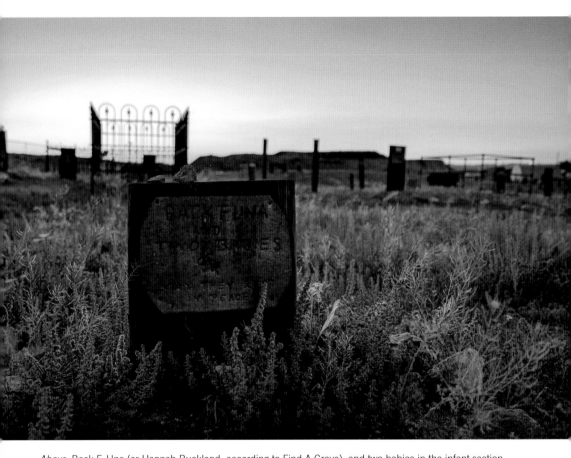

Above: Back F. Una (or Hannah Buckland, according to Find A Grave), and two babies in the infant section.

Opposite page: One of several graves that say "Life Became a Burden" rather than "suicide" for cause of death.

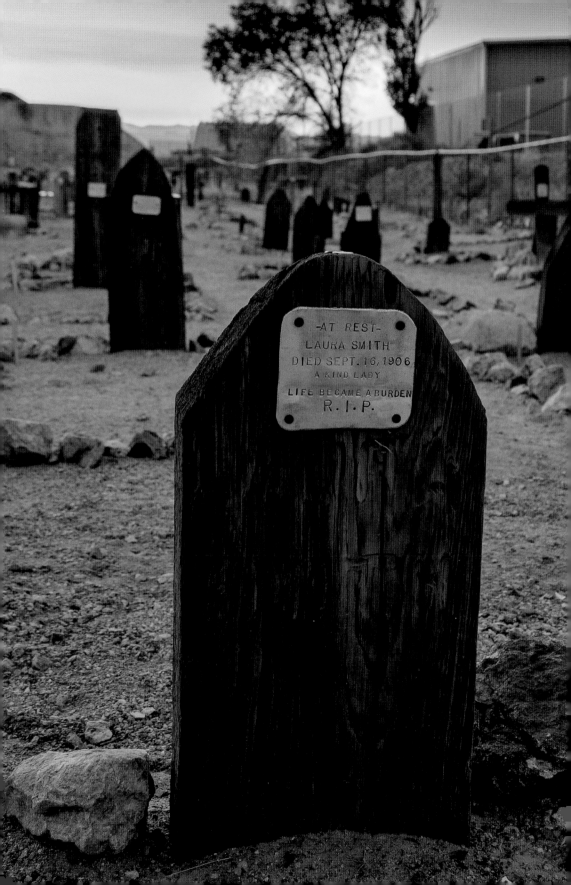

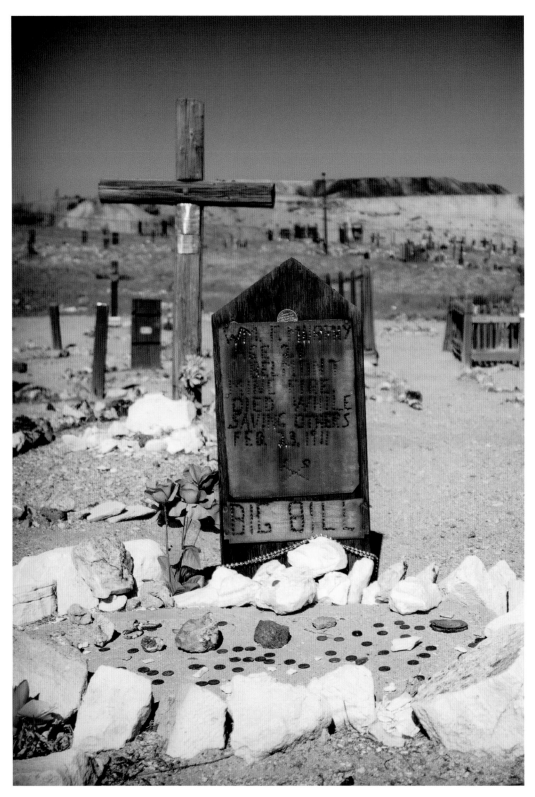

William "Big Bill" Murphy died at age twenty-eight "while saving others."

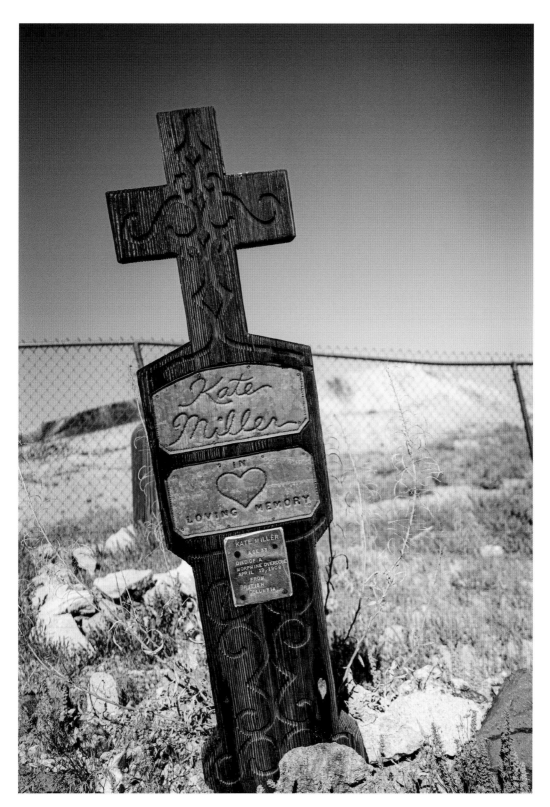

Kate Miller's elaborate grave marker.

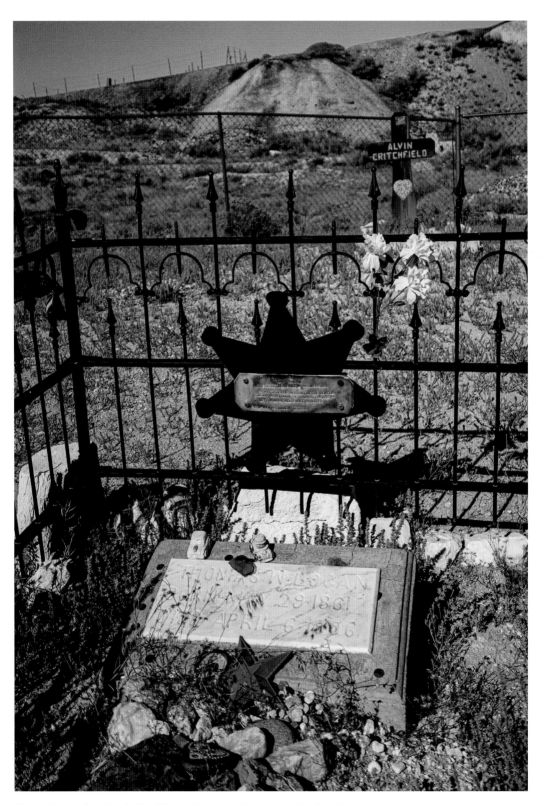

Thomas Logan, Nye County Sheriff for eight years before dying in the line of duty.

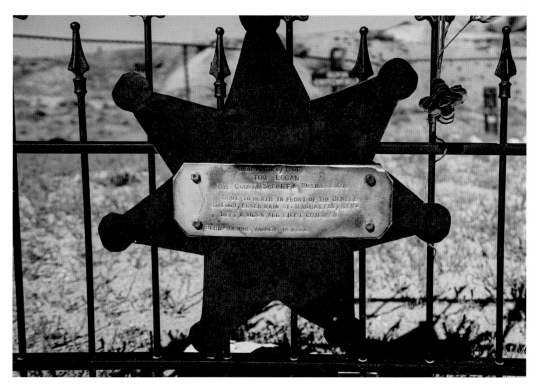

Details about Sheriff Thomas Logan's death.

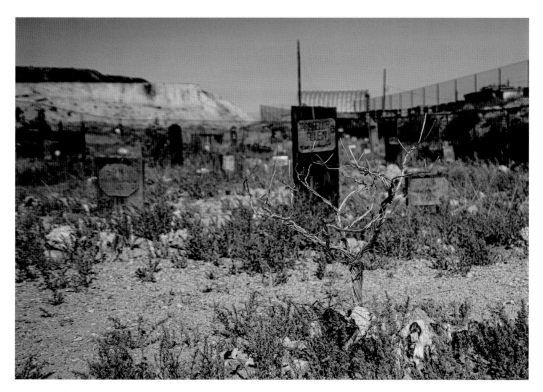

A decorative wire tree in the foreground; the mine looms in the background.

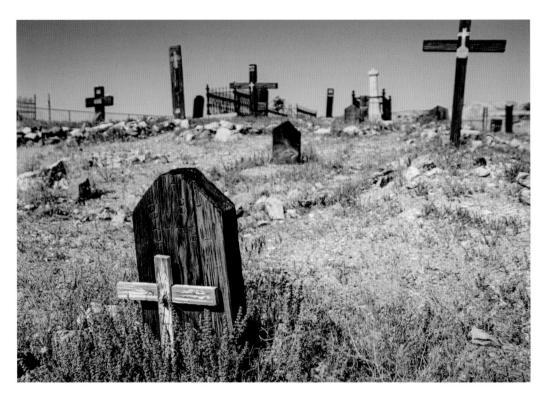

An infant's grave.

Another infant grave.

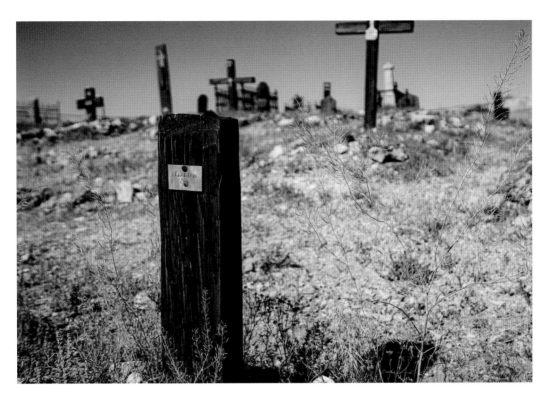

A marker that reads only "Italian."

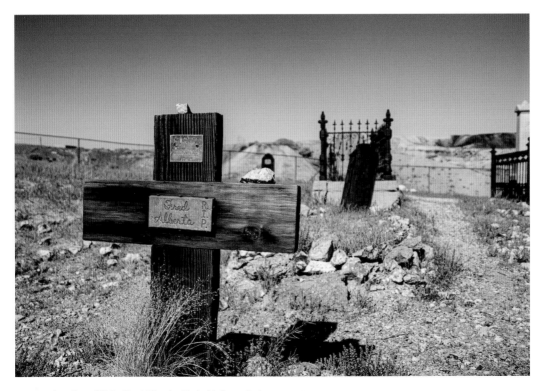

A native of Italy, Fred Alberta died of tuberculosis.

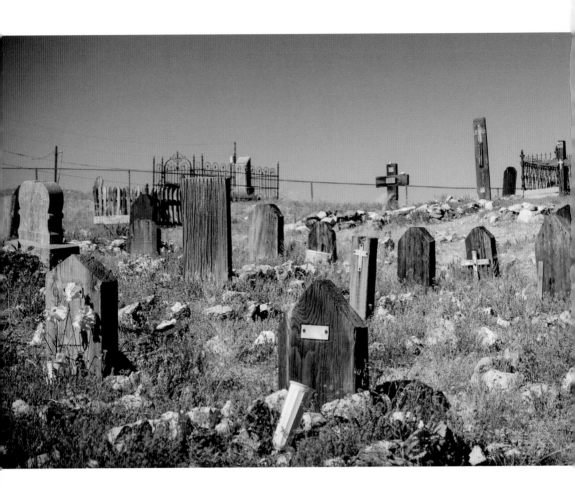

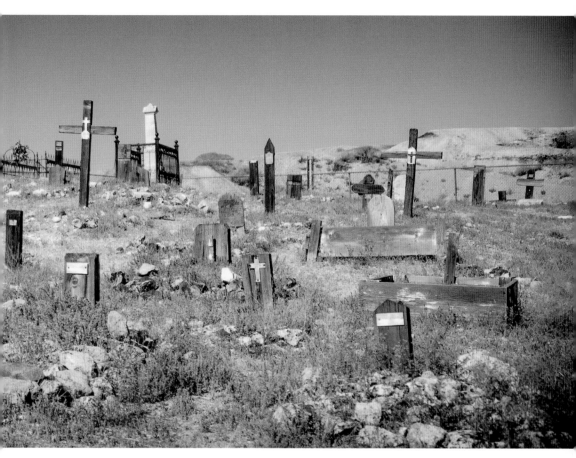

A stunning panorama of Old Tonopah Cemetery.

BIBLIOGRAPHY

"About Fort Churchill." Fort Churchill State Historic Park, Nevada State Parks, parks.nv.gov/parks/fort-churchill

"About Pahrump." Pahrump: True Nevada, Town of Pahrump, 2020. visitpahrump.com/about/

"Ancient America: Nevada." Native American Netroots, nativeamericannetroots.net/diary/1043

Anderson, Clint. "Gold Mining Man." *YouTube*, uploaded by Clint Anderson Family, January 7, 2017. www.youtube.com/watch?v=mzX2dc-oKEM

"Barbara Graham." Murderpedia, murderpedia.org/female.G/g/graham-barbara.htm

Beitler, Stu. "Goldfield, NV Storm, Flash Flood & Drownings, Sept 1913." GenDisasters.com, 2003–2019. www.gendisasters.com/nevada/9297/goldfield-nv-storm-flash-flood-amp-drownings-sept-1913

"Benjamin Nugent." Find A Grave, Findagrave.com, 2020. www.findagrave.com/memorial/24301450/_

"Callisto 'Charlie' Bigongiari." Find A Grave, Findagrave.com, 2020. www.findagrave.com/memorial/39925370/callisto-%22charlie%22-bigongiari

"Candelaria, Nevada." Western Mining History, 2020. westernmininghistory.com/towns/nevada/candelaria/

Cassinelli, Dennis. "Stories of Old Nevada: Hawthorne, America's Arsenal." September 17, 2020, *Elko Daily Free Press*, 2020. elkodaily.com/news/local/history/stories-of-old-nevada-hawthorne-americas-arsenal/article_571bd987-ef76-5a10-a291-2006cc36ba2f.html

"Central Overland Trail." Family Search.org, Intellectual Reserve, 2020. www.familysearch.org/wiki/en/Central_Overland_Trail

"Chief Tecopa Cemetery." Find A Grave, Findagrave.com, 2020. www.findagrave.com/cemetery/1990062/chief-tecopa-cemetery

"Clayton Valley Lithium Project, Nevada, USA." Cypress Development Corp., 2020. www.cypressdevelopmentcorp.com/projects/nevada/clayton-valley-lithium-project-nevada/

"Clown Motel, Tonopah, Nevada." *Atlas Obscura*, 2020. www.atlasobscura.com/places/clown-motel

Coil, David, Elizabeth Lester, Bretwood Higman. "Gold Cyanidation." Ground Truth Trekking, May 27, 2013. www.groundtruthtrekking.org/Issues/MetalsMining/GoldCyanidation

"Comstock Lode—Creating Nevada History." *Legends of America*, 2020. www.legendsofamerica.com/nv-comstocklode/

Cowboy Junkies. "Mining for Gold." AZLyrics.com, 2000–2020. www.azlyrics.com/lyrics/cowboyjunkies/miningforgold.html

"Daniel Elliott Huger Wilkinson." Geni.com, 2020. www.geni.com/people/Daniel-Wilkinson/6000000024786026531

"David Carlyle." Find A Grave, Findagrave.com, 2020. www.findagrave.com/memorial/109818051/david-carlyle

"Death in the Gas Chamber: 1924." February 8, 2014. American Hauntings, Troy Taylor, troytaylorbooks.blogspot.com/2014/02/death-in-gas-chamber-1924.html

"Desert Submarine Base." Ghost Hunting Theories, January 12, 2019,

"Dora C. Black." Find A Grave, Findagrave.com, 2020. www.findagrave.com/memorial/23012033/dora-c-black

"Dorothy Ione Patnoe." Find A Grave, Findagrave.com, 2020. www.findagrave.com/memorial/23012108/dorothy-ione-patnoe

"Ed Carnes." Find A Grave, Findagrave.com, 2020. www.findagrave.com/memorial/24301445/_

"Edward Hughes." Find A Grave, Findagrave.com, 2020. www.findagrave.com/memorial/24301476/edward-hughes

"El Capitan Casino." Northern Star Casinos, Inc., 2020. elcapcasino.com/

Emerson. "This Isolated Ghost Town In Nevada Was Destined To Fail But The Remnants Are Beautiful." 3 July 2018, Only in Your State, Leaf Group Lifestyle, 2020. www.onlyinyourstate.com/nevada/deadly-history-of-this-town-nv/

Eterovich, Adam S. "Chiatovich Clan." Coratia.org, www.croatia.org/crown/croatians/www.croatians.com/CLAN-CHIATOVICH-S.htm

"Gene Robertson." Find A Grave, Findagrave.com, 2020. www.findagrave.com/memorial/72699156/gene-robertson

"George Hearst—Father of a Mining and Publishing Empire." *Legends of America*, 2020. www.legendsofamerica.com/we-georgehearst/

"Ghost Dance Shirts: A Spectacular (and Heartbreaking) Art." Notes from the Frontier, 2020. www.notesfromthefrontier.com/post/the-spectacular-and-heartbreaking-art-of-ghost-dance-shirts

Goldfield Chamber of Commerce, www.goldfieldnevada.org/

"Goldfield Historic Cemetery." Travel Nevada, 2020. travelnevada.com/historical-interests/goldfield-historic-cemetery/

"Goldfield, Nevada." Western Mining History, 2020. westernmininghistory.com/towns/nevada/goldfield/#:~:text=Goldfield%20was%20the%20site%20of,Earp%20also%20called%20Goldfield%20home.

Guthrie, Woody. "Miner's Song." BMG Rights Management, YouTube, www.youtube.com/watch?v=QayWmQ2PoH8

"Hannah Buckland." Find A Grave, Findagrave.com, 2020. www.findagrave.com/memorial/14022505/hannah-buckland

Harding, Adella. "Lode-Star's Goldfield Project High Grade," February 26, 2020. *Elko Daily Free Press*, 2020. elkodaily.com/mining/lode-star-s-goldfield-project-high-grade/article_8f511970-c6b8-5626-a8be-177ac87c4676.html

"Hawthorne, Nevada." Mineral County, 2015. mineralcountynv.us/departments/index.php

"Hawthorne, Nevada Population 2020." World Population Review, 2020. worldpopulationreview.com/us-cities/hawthorne-nv-population

Henley, David C. "Wovoka, Buried in Schurz, Remains Hero to Many," March 15, 2018. *Nevada Appeal*, Swift Communications, 2005–2020. www.nevadaappeal.com/news/opinion/wovoka-buried-in-schurz-remains-hero-to-many/

"Henry Genie." Find A Grave, Findagrave.com, 2020. www.findagrave.com/memorial/109817512/henry-genie

"History of Buckland Station State Historic Park." Fort Churchill State Historic Park, Nevada State Parks, parks.nv.gov/learn/park-histories/buckland-station-history

"The History of Goldfield." The Goldfield Historical Society, 2019. www.goldfieldhistoricalsociety.com/history.html

"History of Nevada." State of Nevada Joint Information Center, State of Nevada, 2019. jic.nv.gov/About/History_of_Nevada/

"Home Means Nevada." State Symbols USA, statesymbolsusa.org/symbol-official-item/nevada/state-song/home-means-nevada

Jennifer. "Why This One Little Town Is Nevada's Best Kept Secret." April 17, 2016, Only in Your State, Leaf Group Lifestyle, 2020. www.onlyinyourstate.com/nevada/best-kept-secret-tonopah-nv/

"John Chiatovich." Find A Grave, Findagrave.com, 2020. www.findagrave.com/memorial/5191017/john-chiatovich

Kyser, Kay. "Praise the Lord and Pass the Ammunition." Sony/ATV Music Publishing LLC, www.google.com/search?q=praise+the+lord+and+pass+the+ammunition+lyrics&rlz=1C1CHBD

LeDoux, Chris. "Raised by the Railroad." Sony/ATV Music Publishing LLC, LyricFind, www.google.com/search?rlz=1C1CHBD_enUS732US733&sxsrf=ALeKk035q2MsE7nQL

Luce, Stewart. "Virgil Walter Earp in Goldfield." The Goldfield Historical Society, 2019. www.goldfieldhistoricalsociety.com/featured-storyVirgilWalterEarpGoldfield.html

"Man Unknown." Find A Grave, Findagrave.com, 2020. www.findagrave.com/memorial/24301650/_

"Map of Nevada Tribes." Nevada Indian Commission, 2015–2020. https://nevadaindiancommission.org/map-of-nevada-tribes/

"Margaret Chiatovich." Find A Grave, Findagrave.com, 2020. www.findagrave.com/memorial/132794974/margaret-j.-chiatovich

Marschall, Peter. "Hawthorne." September 27, 2010, Online Nevada Encyclopedia, www.onlinenevada.org/articles/hawthorne

McCracken, Bob. "Chief Tecopa Kept Peace during Tumultuous Change for Area Paiutes." *Pahrump Valley Times*, August 22, 2016, *Las Vegas Review-Journal*, Inc., 2020. pvtimes.com/community/chief-tecopa-kept-peace-during-tumultuous-change-for-area-paiutes/

McCracken, Bob. "Meet the legendary John Moss," August 9, 2013, *Las Vegas Review-Journal*, Inc., 2020. pvtimes.com/news/meet-the-legendary-john-moss/

Mehak. "7 Must-Do Things On Your Visit To Hawthorne, Nevada—Updated 2020." July 6, 2020, Trip101, trip101.com/article/best-things-to-do-hawthorne-nv

"Mina, Nevada Overview." The Diggings, 2020. thediggings.com/places/nv0212583941

"Mina, Nevada Population 2020." World Population Review, 2020. worldpopulationreview.com/us-cities/mina-nv-population

"Mina, NV." SilverStateGhostTowns.com, 2008. silverstateghosttowns.com/mina.html

Moreno, Richard. "Goldfield Part 1: Site Remains One of Nevada's Most Fascinating Neo-Ghost Towns," May 31, 2018. Nevada Appeal, Swift Communications, 2005–2020. www.nevadaappeal.com/news/lahontan-valley/goldfield-part-1-site-remains-one-of-nevadas-most-fascinating-neo-ghost-towns/

Mueller, Megg. "True Grit: Hawthorne." July–August 2019, *Nevada Magazine,* 2015–2020. nevadamagazine.com/issue/july-august-2019/10792/

"Nevada—History and Heritage." *Smithsonianmag.com*, November 6, 2007. Smithsonian Institution, 2020. www.smithsonianmag.com/travel/nevada-history-and-heritage-9432136/#:~:text=Spanish%20explorers%20approached%20the%20area,legendary%20Kit%20Carson%2C%20John%20C.

Niller, Eric. "How the Second Industrial Revolution Changed Americans' Lives." January 25, 2019, History.com, A&E Television Networks, LLC, 2020. www.history.com/news/second-industrial-revolution-advances

"Norman N. 'Curly' Coombs." Find A Grave, Findagrave.com, 2020. www.findagrave.com/memorial/97738722/norman-n-coombs

"Old Tonopah Cemetery." Find A Grave, Findagrave.com, 2020. www.findagrave.com/cemetery/2174134/old-tonopah-cemetery

"Old Tonopah Cemetery (1901–1911)." Online Brochure, Town of Tonopah. www.tonopahnevada.com/CemeteryBrochureOnline.pdf

"Old Tonopah Cemetery, Tonopah, Nevada." *Atlas Obscura*, 2020. www.atlasobscura.com/places/old-tonopah-cemetery

"Our Communities." Nye County Nevada, 2006–2020. nyecounty.net/797/Our-Communities

"Pinenut Festival." NativeAmerica.Travel, American Indian Alaska Native Tourism Association. nativeamerica.travel/listings/pinenut-festival

Riggs, Ransom. "Desolation Vacation: Mina, Nevada." October 21, 2009, *Mental Floss*, www.mentalfloss.com/article/23065/desolation-vacation-mina-nevada

Rossetti, Christina. "Let Me Go." Funeral Guide, 2020. www.funeralguide.co.uk/help-resources/arranging-a-funeral/planning-the-service/funeral-poems/let-me-go

"Samuel L. Gaunce." Find A Grave, Findagrave.com, 2020. www.findagrave.com/memorial/13695430/samuel-l.-gaunce

Sebesta, Paul. "Bonnie Claire." Nevadapedia. www.nv-landmarks.com/towns-ab/bonnieclaire.htm

"Silver Peak, Nevada." Esmeralda County, Nevada, 2019. www.accessesmeralda.com/communities/silver_peak.php

"Thomas Stead." Find A Grave, Findagrave.com, 2020. www.findagrave.com/memorial/114644380/thomas-stead

"Tombstone Latin." 1999 Ad Fontes Certamen, Level IV—Final Round. www.thelatinlibrary.com/certamen/afa4.finals.html

"Tonopah-Belmont Company Belmont Mine Fire." Mine Disasters in the United States, United States Mine Rescue Association, usminedisasters.miningquiz.com/saxsewell/belmont_mine.htm

"Tonopah, Nevada." Tonopahnevada.com, 2020. www.tonopahnevada.com/history/

"The True Fissure (Candelaria, Nev.) 1880—1886." Library of Cuongress, www.loc.gov/item/sn86091232/

"The Walker River Paiute Tribe." WRPT.org, 2020. www.wrpt.org/agai-dicutta-numu/

"We Will Be Known Forever by the Tracks We Leave." Minority Business Development Agency, 2006–2020. archive.mbda.gov/news/blog/2012/11/we-will-be-known-forever-tracks-we-leave-santee-sioux-tribe.html

"What Is Lithium Extraction and How Does It Work?" July 31, 2018, Samco Technologies, Inc., www.samcotech.com/what-is-lithium-extraction-and-how-does-it-work/

"Where is Pahrump." Pahrump, Nevada, www.pahrumpnv.org/191/Where-is-Pahrump#:~:text=Pahrump%20is%20about%2035%20miles,Nopah%20Mountains%20to%20the0west

"William Chapman Ralston." Online Nevada Encyclopedia, a Publication of Nevada Humanities, www.onlinenevada.org/articles/william-chapman-ralston

"Wovoka." New Perspectives on the West, PBS.org, 2001. www.pbs.org/weta/thewest/people/s_z/wovoka.htm

"Wovoka – Paiute Medicine Man & the Ghost Dance." *Legends of America*, 2020. www.legendsofamerica.com/na-wovoka/